Black Dogs

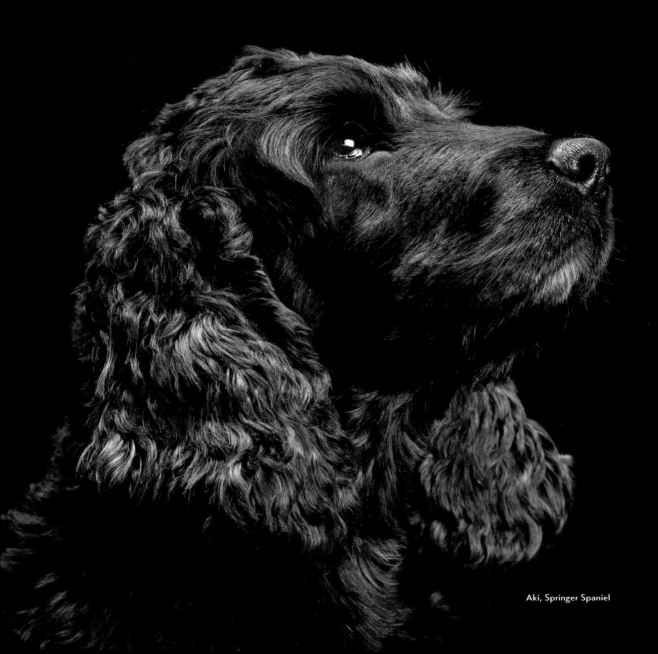

Aki, Springer Spaniel

Black Dogs

Stories of Love and Friendship

PHOTOGRAPHY BY

Fred Levy

EPIC INK

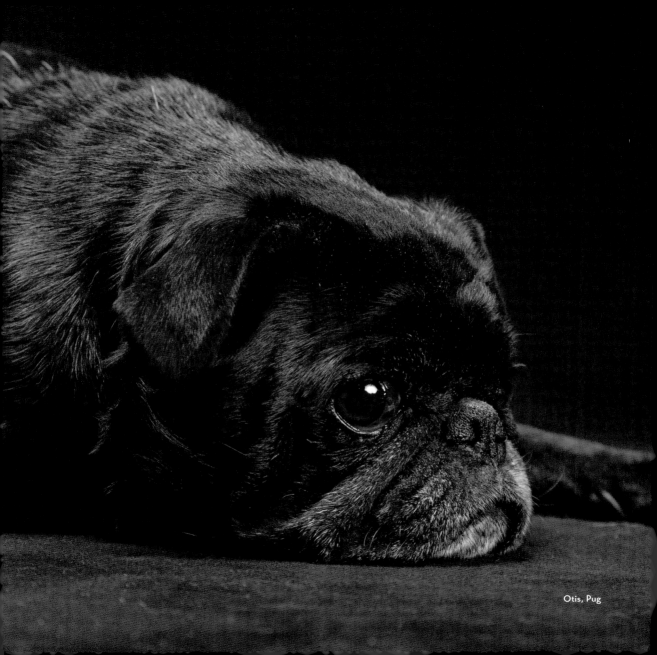
Otis, Pug

This book is dedicated to my family who
stood behind me so I could follow my passion and create a work
that makes a difference in the world.

This book is also dedicated to the gorgeous creatures
whose images grace these pages and the amazing humans who love them.
Thank you to those who have taken up this cause and have used this idea to help
promote rescues around the world. Until all the shelters are empty and every pet is
in a good home, we will all need to keep speaking up for those who can't.

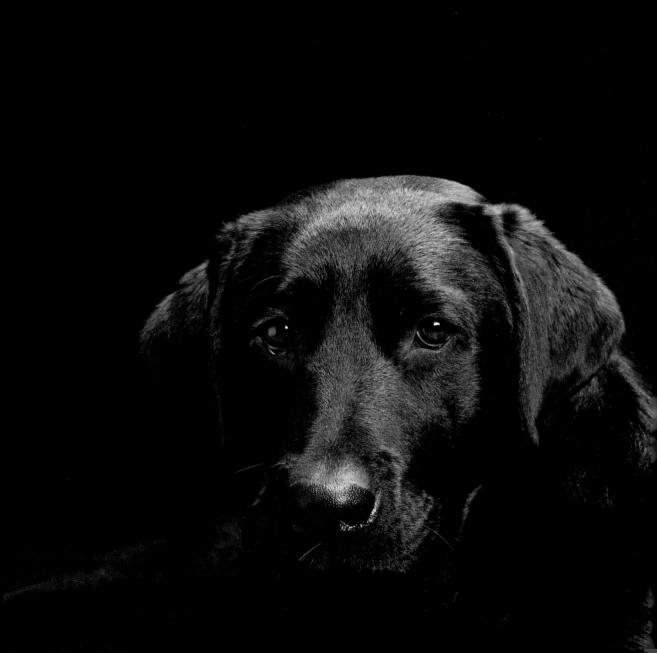

Rosie & Suzie, Labradors

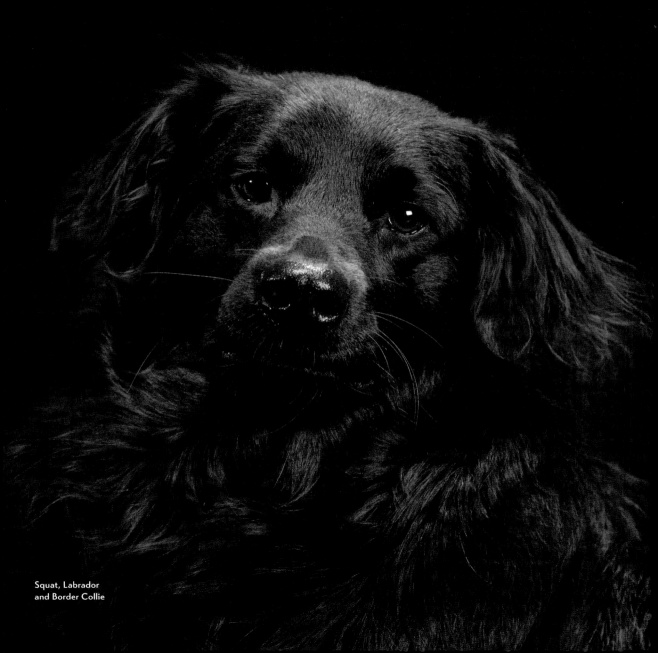

Squat, Labrador and Border Collie

Contents

Foreword 16

Introduction 20

Dakota
Keeshond and Miniature
Pinscher Mix **25**

Naina
Alpenhutehund **29**

Norman
Pit Bull and English
Bulldog Mix **33**

Zoey
Labrador Mix **26**

Denver
Labrador **30**

Chance
Labrador **34**

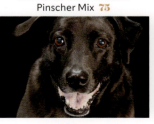
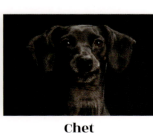

Day-Z
Brussels Griffon 61

Patrick
Toy Poodle 71

Duncan
Cocker Spaniel 79

Lexi
Labrador Mix 62

Mercedes Ann
Standard Poodle 72

Sophie
Labradoodle 81

Teddy
Labrador 65

Oscar
Chihuahua and Miniature Pinscher Mix 75

Emmi
Labrador Mix 82

Beau
Labrador Mix 66

Abby
Labrador 76

Chet
Mixed Breed 85

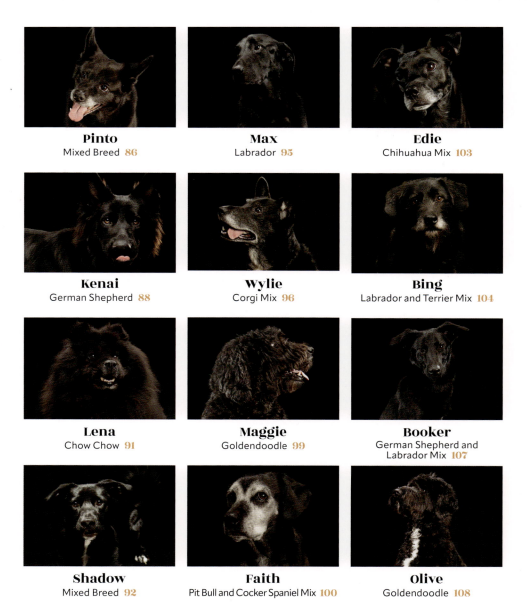

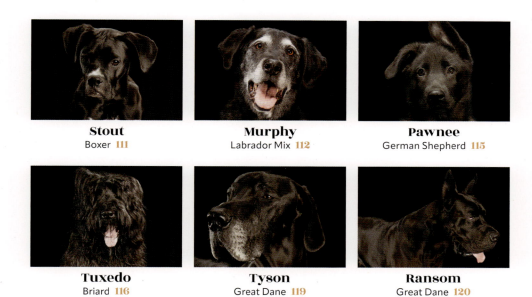

Stout
Boxer 111

Murphy
Labrador Mix 112

Pawnee
German Shepherd 115

Tuxedo
Briard 116

Tyson
Great Dane 119

Ransom
Great Dane 120

Acknowledgments 124

About the Photographer 125

About Labradors and Friends Rescue Group 127

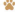

Crickett, Spaniel Mix

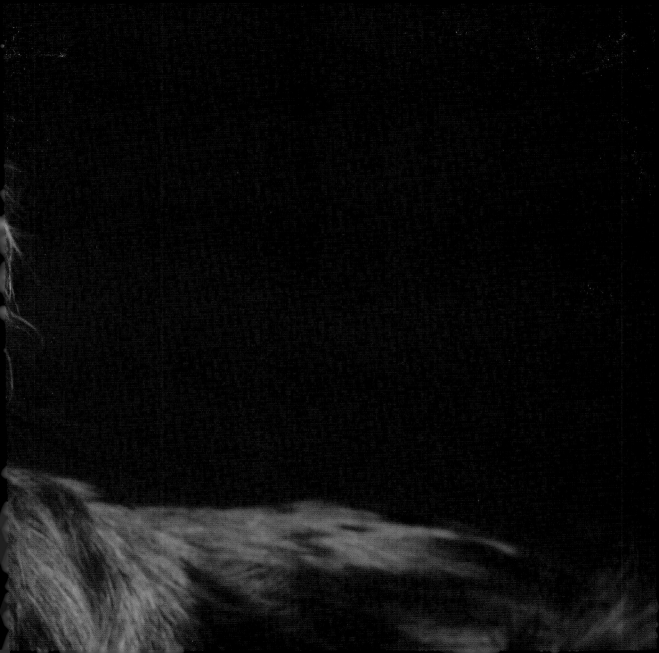

Foreword

Ever since I was a young child, I have always had a love for black dogs. My best friend growing up was a black schnauzer named Jerry. He was a rescue, left by his family when he was two, then found by mine. Jerry was with us for twelve wonderful years. I had a knack for finding stray black dogs as a kid, a talent that drove my parents crazy, but I always found them homes. At the time, I didn't understand why so many black dogs seemed to eventually need homes, but I would learn more about that later in life.

As an adult, I started getting involved in rescue, helping shelter dogs get the rehabilitation they needed so they could find new homes. I remember walking to the shelters and seeing so many big black dogs staring back at me. Some were purebred, others generic mixes, but all were beautiful to me. I would go week after week, usually seeing many of the same faces, watching them get sick and depressed and losing their once-happy demeanors to a reality I didn't want to believe back then. I was naïve in those early years.

Fourteen years ago, I was in the South Los Angeles Shelter doing evaluations on the dogs for the rescue I was volunteering for at the time. The purebred rescue was also there doing their evaluations. We were both looking at two dogs, a yellow Lab and a black Lab. Both had great temperaments, were similar in age, and were clearly purebred Labradors. The breed-specific rescue declined the black Lab for no real reason; they just said they could only take one, so they took the yellow. Why would one be better than the other?

In 2007, we formed Labradors and Friends Dog Rescue Group (LFDRG), and the organization became my passion. As a founding member, I felt a tremendous responsibility

to help the Labs, mixed breeds, and other great dogs that had been left behind in a failing shelter system. Our logo is the quintessential black Lab holding a tennis ball; after all, they are the original Labrador. It was right around the time we started LFDRG that I started to see magazines and news articles about the so-called "Black Dog Syndrome" in shelters. Immediately, something in me clicked. Could this be what I had been seeing for years? Had other people noticed, too? And while I was relieved it wasn't just me noticing the issue, it was still so sad that people were continually passing over black dogs for adoption.

I have been blessed to have many great black dogs in my life. Each one has taught me so much and led me on the path and journey that I am on today. In November 2014, I lost my heart dog—a big, beautiful black Lab named Boomer. We rescued Boomer's mom, Grace, three days after she gave birth in our local shelter. Boomer was the only black male, and I knew from the moment he was born that he was coming home with me. I watched him grow, taking pictures and making memories all along the way. He was my constant companion and true friend. So many people would be afraid of him because of his size and color until they got to know him, and then they would realize he was just a gentle giant. His eyes would melt your heart, and his loving way would give you strength to go on during difficult times. He helped many people see the beauty in black dogs, so I dedicate this foreword to you, my Boomer. We will continue to educate together as you are forever with me and my inspiration.

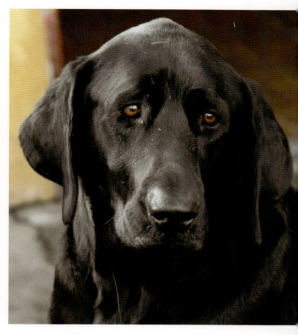

Boomer (April 5, 2006—November 17, 2014)

Lauren Dube
Cofounder and President of Labradors and Friends Dog Rescue Group

17

Iggy and Jack-Jack,
Boxer and Boston
Terrier Mix and
Chihuahua Mix

Introduction

"I can never get a good photo of my black dog."

It's a statement I've heard many times while out taking photos of dogs at my local dog park. I get it. As a photographer, I understand how light works and how the camera sees, so when people want to take a nice photo of their dog, and it doesn't come out as well as they expected, I understand.

While at that same local dog park on a bright sunny day in 2013, however, a woman mentioned something to me about black dogs that I *hadn't* heard before. She told me that black dogs have a harder time getting adopted than other dogs in shelters. Now, I see black dogs all the time, and even though I'm pretty invested in the pet world, I had never heard about this, and it was so disheartening.

That was my starting point for the Black Dogs Project. I love working on personal projects to flex my photographic muscle and see how much I can shoot and learn about a particular subject. I was already looking for a new project because my last project on dog parks was coming to a natural end, and I was ready for a new challenge. I knew I wanted to get better at studio lighting and didn't have a lot of free time, so I figured I could shoot dogs in my home studio. I wanted to make black dogs look as beautiful on camera as they look in real life.

With a little help from some friends and social media, I started asking around and quickly got my first black dog to come to the studio. What a great experience! Susan

and her son brought Kenai, their German shepherd (see page 88). Then my boys and my dog, Toby, came down in the middle of the shoot, just to make it a completely crazy space. From that first shoot, I knew I was onto something. I wanted to reach out to a wider audience that loved both dogs and photography, and this project was really going to do that.

I kept reaching out, and friends of friends would tell even more friends about the photographer who wanted to take photos of their black dog. My calendar began to fill up, and each shoot would bring a new round of challenges and another amazing story about a black dog.

When all of this started, I gave myself some guidelines that I tried to hold on to but, like all unreasonable restrictions, they fell apart really quickly. Originally, I only wanted all-black dogs for the photo series, but when people contacted me and showed me photos of their black dogs with some white on them, I just couldn't say no. Especially if they were senior dogs. I have such a soft spot for them, because I know they aren't much longer for this world.

Once the project reached that tipping point, and the Black Dogs Project blog (caninenoir.tumblr.com) started to get some good press, I started being contacted by so many different people from all over the world. My inbox exploded with emails from people asking about the project, telling me how important their black dog is to their family, or recounting crazy stories about someone's reaction to their black dog.

I was humbled. I had no idea it would be so big. I heard about people adopting black dogs simply because of my photos. One mother sent me photos of her black dog who supported her son while he went through chemotherapy (he is now off to college). I heard funny tales about little old ladies making the sign of the cross and racing back to their homes whenever they came upon a black dog. And I've heard stories that aren't so funny: people crossing the street to avoid black dogs, and black dogs being ignored by the not-so-friendly stranger who stops to pet a non-black dog brother or sister.

It really made me wonder why this was such a big thing all over the world. Some people have speculated that it is tied to cultural and race issues in America. In England, Winston Churchill called his depression his "black dog," while in India, black dogs are brought into the home to absorb all the bad energy. Both literature and mythology have long histories

of featuring negative portrayals of black dogs; for instance, in the Harry Potter series, the Grim is a black dog that is an omen of death.

The truth is that no one knows for sure if there is a single or many reasons why Black Dog Syndrome exists. From my perspective, I think our online shopping culture is partly to blame for the widespread issue. When we want something, we frequently go online and buy it, and we are accustomed to being "sold" a product with loads of glamour shots, good lighting, and up-close details. Rescues and shelters don't have a budget to "sell" their dogs and often rely on volunteers to take photos of the dogs to promote their adoptions online. And taking a photo of a black dog in a white kennel means you won't see much more than an outline of what should be a dog. And it's tough to see personality or a big heart in an outline. One bad photo on an online adoption site could mean a dog never finds his forever home, and that is a tough thing for me to accept as both a photographer and a dog lover.

It's important to recognize what has changed since this book first came out. Every dog has lived their best lives, and many have since passed away. We had to say goodbye to our dog, Toby, who we still miss but were so grateful for. But we now have two rescues, Iggy and Jack-Jack. Two black dogs that now live a great life.

My hope for this project isn't that everyone will want to go out and get a black dog. My hope is that people will take this kind of knowledge about black dogs and keep it in mind when deciding to bring an animal into their lives. This is why I am donating a portion of the royalties from this book to Labradors and Friends Dog Rescue Group in San Diego to raise awareness of this issue. After all, pet adoption is taking the responsibility to raise and protect a life and to hopefully give that animal the best life possible. So choose thoughtfully, and you will be rewarded in more ways than you'll ever know.

Fred Levy

Triton, French Water Dog

Dakota
Keeshond and Miniature Pinscher Mix

The first time that we saw Dakota, we were amazed at how sweet he was. I saw him on the Animal Rescue League's website and thought we should go visit with him. I had a migraine the day we met him, and the first thing Dakota did when he stepped out of the kennel was to climb up onto the bench where I was sitting and sniff my face. My husband, Brett, said Dakota could just tell that I wasn't feeling well and wanted to make me feel better. We knew right then that he was going to be our dog.

I was having a really bad time right before we adopted Dakota. I was struggling with anxiety attacks and had a hard time coping with some life changes. And because Brett worked a lot of late hours and weekends, there were times when I was home alone, and it made me feel depressed and lonely. I did some research and learned that dogs can really help with depression and other mental health disorders as an alternative to therapy, and Dakota has honestly been one of the best non-medical therapies for me. He makes me smile when I'm down, and he'll just listen to me talk when we're home alone together. I feel like I can laugh or cry with him, and he'll just understand.

Aside from his floppy ears, Dakota's best quality is being in tune with other people and animals. About two months after we adopted him, we took him to the vet and there was a senior dog there who was fighting cancer. Normally, Dakota gets very agitated and anxious around other dogs, but this time it was totally different. He just sat down next to the sick dog and nudged him almost as if to say, "What's wrong? Can I help?" That's when I really knew Dakota was special.

Christina and Brett

Zoey
Labrador Mix

Zoey was saved by a rescue organization that found her and her siblings abandoned in South Carolina. When my husband and I began looking for a dog to adopt, we knew we wanted a rescue.

We saw Zoey and it was love at first sight. Her blue eyes, especially contrasted against her black fur, captivated us. Her playful, loving, and spunky personality won us over immediately. She was only thirteen weeks old and had a ton of puppy energy (and still does). Despite her rough start in life, she was such an affectionate dog. She would even take pauses between fetching and playing to give us lots of kisses.

One of our favorite things about Zoey is her zeal for life. She loves everything she does. As soon as we get our shoes out of the closet, she sits and waits as patiently as she can at the door, hoping for any kind of trip outdoors. Her enthusiastic tail-wagging always gives away her excitement. Car rides are one of Zoey's favorite activities, *especially* when the windows are down. Although walks and car rides are some of her favorite things, Zoey's greatest happiness comes from playing with other dogs. She's bigger than a lot of dogs now, but she is always gentle no matter their size. She is very outgoing and loves engaging the other dogs in play, her tail wagging (more like whipping) all the while.

We are so glad that we are able to provide a home for Zoey. Adding her to our family has changed our lives. Her genuine joy and love for life influence and inspire us every day.

Jackie

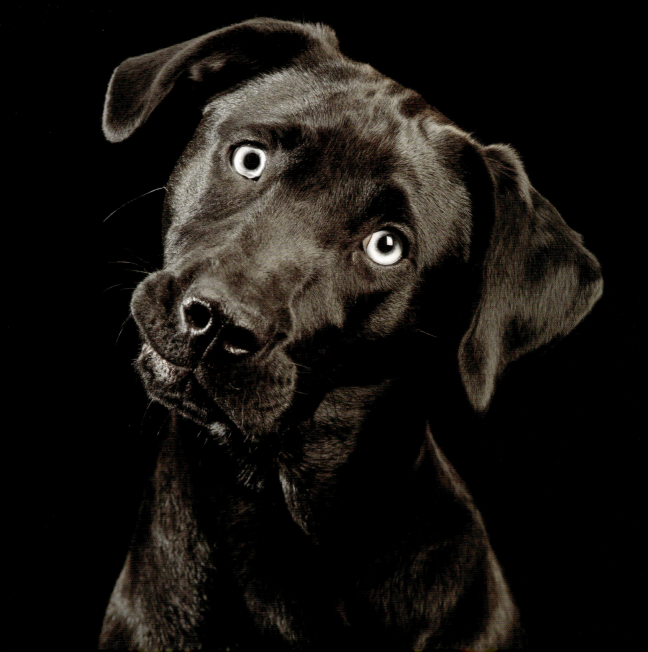

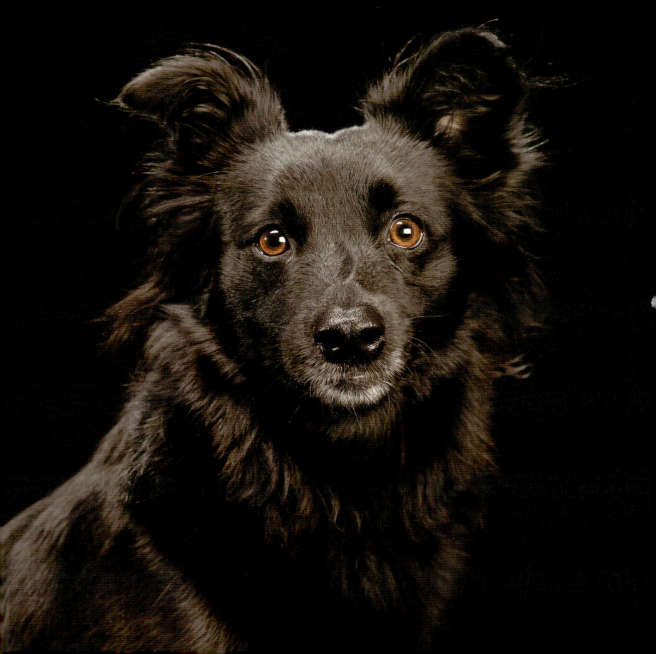

Naina
Alpenhutehund

Naina's eyes were the first thing I noticed about her. They were big, terrified, and very beautiful. It seemed only fitting that I call her Naina, which means "eyes" in Urdu. At eleven months old, Naina had already been through a lot. Six of the eight puppies in her litter had died of parvovirus in a high-kill shelter in Tennessee. Naina was placed in a home with two hyperactive children whose father hit Naina out of frustration a few times, prompting her to seek shelter under the nearest bed or couch (something she still does when scared). He once tried dragging her out by her muzzle and when she nipped him, the family shipped Naina out.

That first day I met Naina, she spent the entire evening apprehensively watching me from behind her foster mother's legs. Her eyes were just crying out for a stable, comfortable home.

I was allowed to take Naina to work with me, and being in an environment where everyone gave her love—while still giving her space—was exactly what she needed. Her personality, with all its curious little quirks, came out in full force. Naina has been known to take my baby niece's stuffed animals out of her room and line them up on the couch, facing the television. She once figured out how to open my mini fridge, a discovery that cost me half a block of vintage Cabot's cheddar.

Naina and I are quite inseparable now. The worst part of my day is leaving for work and looking back to see the tips of her ears twitching above the windowsill. By the same token, the best part is returning home to her ecstatic, furry love.

Some days when I see her, fluffy tail aloft, legs moving furiously as we run by the Charles River or she chases snowballs, I can hardly believe that she is the same dog from that first day. Most of my friends refer to us as "Rohit and Naina" because we are a unit now. She is the single most important thing to me in the world.

Rohit

Denver
Labrador

When I first got Denver from the breeder, I was still so attached to the previous service dog I had trained, Owen, that it was hard for me to start a new bond with this little puppy. It scared me! This was my first dog that I was buying, raising, and training on my own. What if he didn't like me?

Denver and I had a hard time bonding the first month. I kept calling him Owen. Then one day I got a call to bring Denver to Boston to visit the fire stations and first responders of the Boston Marathon bombings. I was so nervous, but Denver spent six hours that day being petted, held, and hugged. Tears welled up in my eyes as the men of Ladder 33 placed him in their boots, on their jackets, and even in the fire truck. At less than three months old, my dog was providing comfort and love to hundreds of people. I knew on the drive home as I held him that he was my dog.

These days, Denver enjoys going to daycare—he loves the girls that work there and even has a few canine girlfriends! He is the most generous, big-hearted dog I've ever met. If he sees me upset or crying, he will curl up next to me in bed, lick my face a few times, and let me know it's okay, as though he's saying, "I'm here, and I will listen."

Twice a month, we visit my mom's third-grade class, where Denver helps kids with special needs. He spends time letting the children pet him and talk to him. I cannot tell you how much those children look forward to his visits.

Denver is a protector by nature. One night I was swimming at my summer home, and I dove underwater. When I surfaced, I was greeted by a panicked black Lab. Denver thought I was in trouble and swam all the way out to look for me! It's such a comfort knowing that Denver will always have my back. And, Denver, I will always have yours!

Amanda

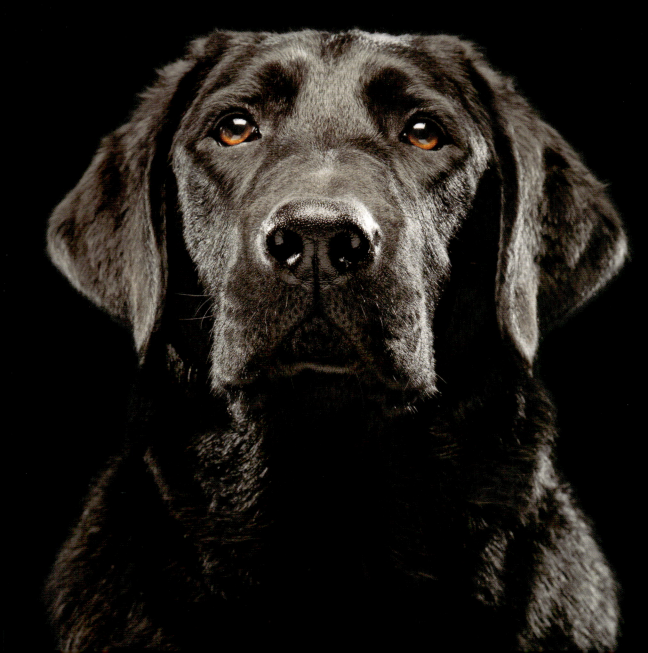

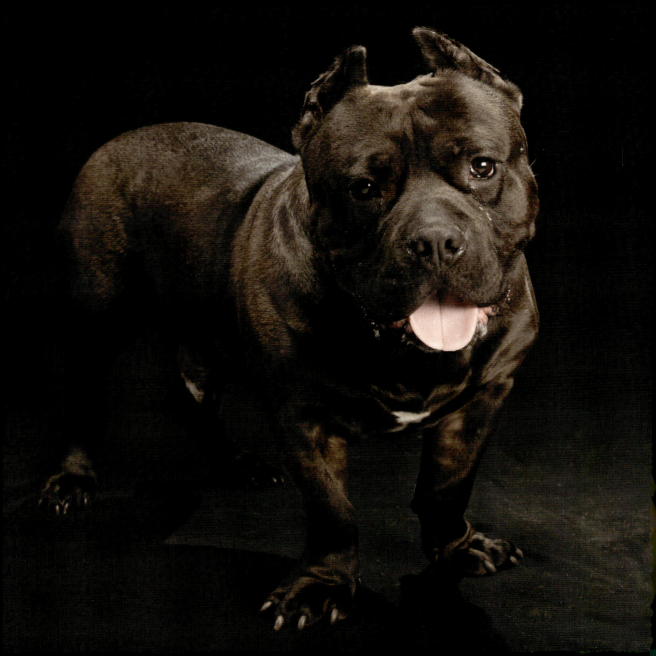

Norman

Pit Bull and English Bulldog Mix

My dog Norman came into my life by accident. I had recently lost two dogs a month apart from each other, and I was not actively looking for a dog. My kids were a different story, though. They couldn't stop looking for dogs, and before I knew it, we were on our way to bring home our newly adopted Chihuahua, Jemma. Then my wife saw Norman on the website thankdogrescue.org. Thanks to his big head, short legs, and goofy stance, she was hooked. She needed to meet him.

Norman was here the following week. He was adopted from Thank Dog Rescue out of Connecticut, after being found as a stray, skinny and neglected, running the streets of Long Island in New York. He had been picked up off the street by animal control and placed in a high-kill shelter when the incredible people of Thank Dog pulled him.

Thank Dog Rescue tried to place Norman in other homes, but he was turned away for one reason or another. Then Norman came here. When I first laid eyes on him, I couldn't believe how short he was! His body is huge, but his legs are tiny. His first interaction with my three-year-old was incredible. Norman played so nicely, even though he is a solid eighty-five pounds (39 kg)! His attitude toward my children and Jemma made me realize that he was a good fit.

Norman really took to us right away, and his foster parents realized that our family was right for him. During his first night at our home, Norman wouldn't go to bed until all of his new family members were upstairs. He came into my room, jumped up onto my bed, and snuggled up to me. That night no one got any sleep. Norman snores—loudly, I might add— and grunts and makes all sorts of weird noises.

Every day when I get home from work, I get a wet greeting of kisses from Norman, Jemma, and my children. He could not be a better fit for my family and me.

James

Chance
Labrador

The moment I saw Chance, it was love at first sight. Older dogs are usually more difficult for rescues to place, and black dogs are especially difficult—usually the last to be adopted. I am not young and therefore thought that I could give an older dog a good home during my later years.

I looked at many dogs on rescue websites, but none clicked. Then I saw Chance. He was being fostered by a family nearby, so I drove to see him. He immediately came over to me and put his head on my knee and looked up at me. I knew that he had chosen me.

I know nothing about Chance's history other than the fact that he came from Chattanooga, Tennessee. He is friendly, kind, and gentle—a real people dog. He is also skittish with loud noises. He is terrified of water coming out of hoses and of the freezer door opening and closing—not the refrigerator door, only the freezer door. When he first came to my home, he would not go into the kitchen.

Chance is great with people and with other dogs. He has a best friend, Puppy, whose owner and I like to go for walks together. As soon as the dogs get out of the car, they run up to each other, bump into one another, and start rolling and tumbling together. They actually greet each other with a kiss.

When Chance wants something, he will come up to me and talk, with a "rowl, rowl, rowl" sound. If he is hungry and I ask him what he wants, he will lead me to his food dish, look at it, look at the container of food, look back at me, and go, "Rowl, rowl, rowl," again. If he wants to go out, he leads me to the door, again talking to me. I think that is the most endearing quirk that he has. It shows his intelligence and his ability to think and try to get me to understand what he wants.

I can't imagine life without my big black friend.

Anne

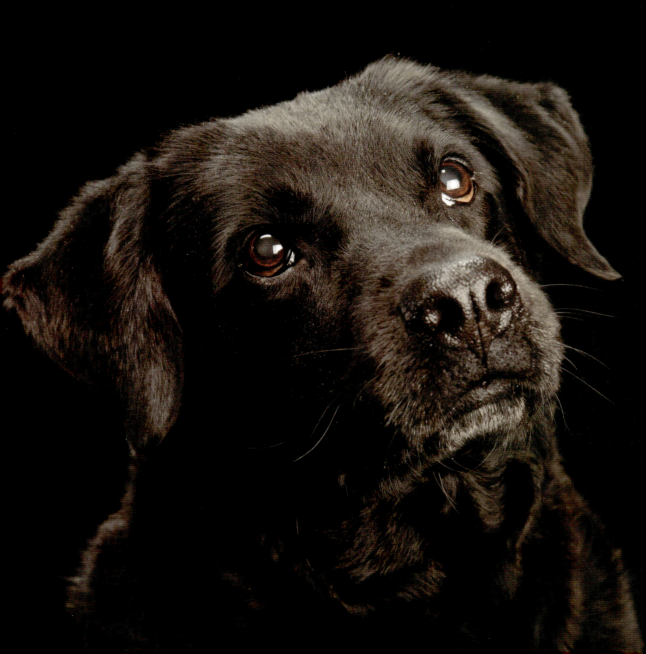

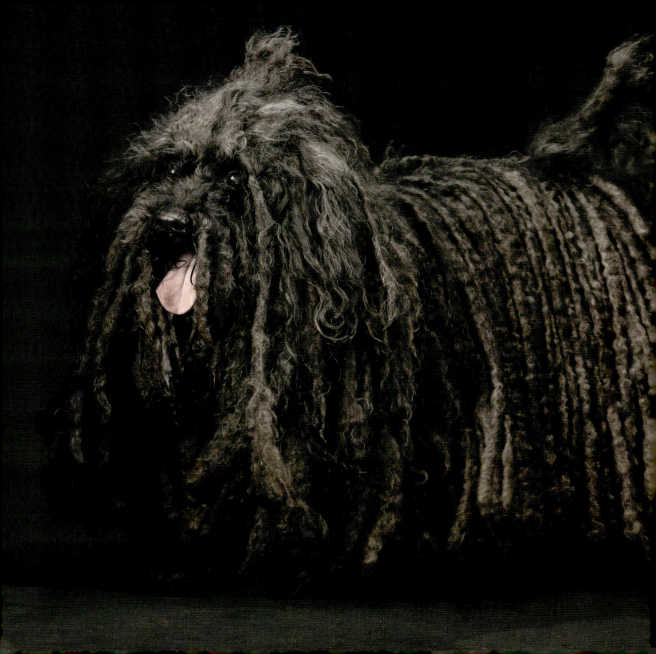

Arlo
Puli

I fell in love with Arlo the minute I saw him at Logan International Airport in Boston. He was four months old and very tired after a twenty-eight-hour flight from Hungary. Those brown eyes are as beautiful now as they were twelve years ago when he first opened them in Boston. His ears still tilt backward on occasion, and he still sometimes squeaks when he yawns, like he did as a puppy.

The puli is a herding dog, about thirty-five pounds (16 kg), and Arlo is a star of the breed—at least to me. He herds his toys in piles, focusing on his "secret" sleeping spot in a corner under the bedroom window, where he puts his favorite toy. He chooses the toy of the sports season—he seems to know when it's Red Sox "Green Monstah" time or Patriots football season—and puts it in his mouth when he does the dance of joy to greet me when I get home.

Because he is a herding dog, Arlo lets me know that he is in charge. He is bossy, noisy, spirited, and funny. He likes his walks but only to patrol the neighborhood to see if his favorites are outside, so he can schmooze with them, lying at their feet with his hair spread about him like a rug of ropes.

Arlo supplies his own applause during his happiest moments. He will get up on his hind legs, cords flying, and clap. This is what makes Arlo my Arlo.

Diane

Maddy
Labrador

I first met Maddy when my husband and I went to the Sterling Animal Shelter "just to look." The minute we opened the pen for Maddy, we knew she was the one for us. She happily came over and curled right up on our laps. We were informed by the staff that she had been kept a little longer at the shelter because she had suffered an infection. She normally would have already found a home, but she was only ready now. I truly believe that we were her match and that she was waiting for us.

Since that first day when we brought her home, Maddy has been the most wonderful family dog. She immediately found her place for frequent cuddles: draped across my husband's legs. When we brought our newborn daughter home from the hospital about two years later, Maddy stood at the couch and carefully sniffed and licked the top of her head. She was often found standing guard while my daughter slept. She was equally curious when, two years after that, we brought our son home. She puts up with endless play with the kids and is so patient and loving with them. She has put up with toddlers falling on her, clothes being put on her, and kids chasing after her with their toys.

Maddy is *always* ready for any food dropped or tossed her way. She hates the water but loves to sit on the beach next to my chair. She is always waiting eagerly for us to wake up in the morning, and when she sees or hears one of us begin to stir, her tail starts wagging wildly against the floor. She would love to greet and lick every person and every other dog in the world. The love of her life is a springer spaniel whom she sees regularly. The springer spaniel does not get along with other dogs except for his girlfriend, Maddy.

Maddy will always have the place of my first baby in my heart. We love her so much.

Margaret

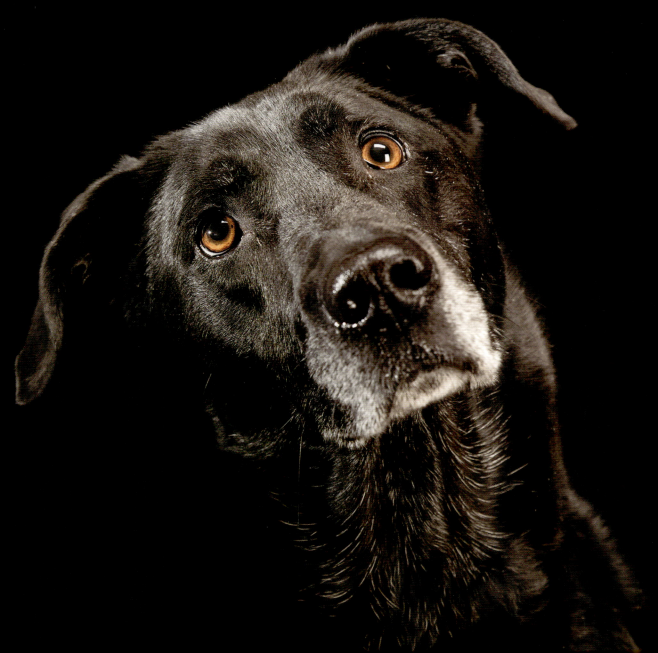

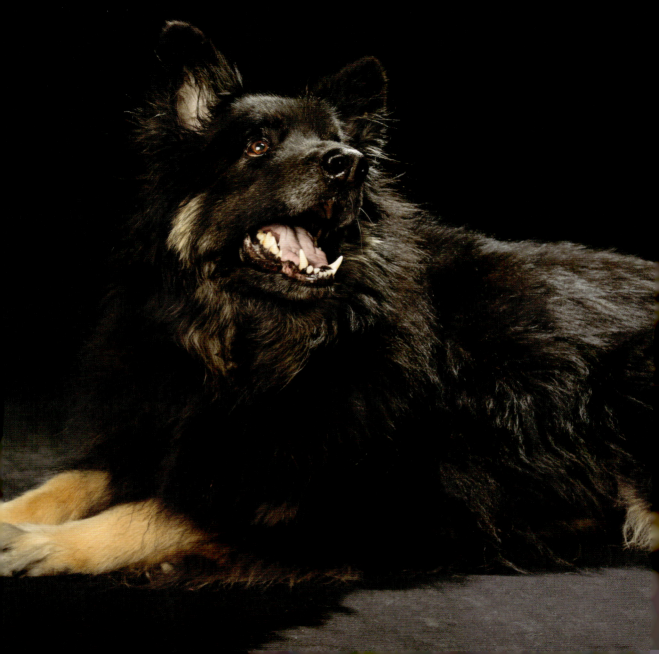

Kendra
German Shepherd

I sought out Kendra for her temperament and look. I love black dogs, and Kendra is my third one.

Kendra picked me out. When I went to visit a kennel to look at a litter of puppies, she locked those eyes on me and the rest was history. She never took her eyes off me until she was in my arms and ready to go home a few hours later.

Because she is a large black dog, people are always intimidated by Kendra. Her intense look seems to go right through you. Kendra is not just a tough face, though; she was a blood donor dog for over five years. She's not just my hero; she has saved many lives.

Kendra instantly became a part of my family and leaves her mark on everyone she encounters. She protects my family constantly. She keeps my mind at ease when I am working and have to leave my daughters at home. I never worry about anyone entering the house with her around!

She is a kind and gentle soul, unwavering and strong, and she forever changed who I am and how I see the world. I am eternally grateful.

Deanna

Clark
Labrador and Pit Bull Mix

In addition to being a black dog, Clark carries the stigma of being part pit bull. It is truly a gift that he exists today.

Clark's mother was a black pit bull mix who used to live on the streets outside Atlanta, Georgia. A kind man who fed her a few times in the neighborhood saw her get picked up by animal control. She was almost full-term with Clark and his littermates when the man rescued her from being euthanized. He brought her to a local animal hospital, where she gave birth to seven healthy black puppies. Although all of the puppies were black and part pit bull, the animal hospital found homes for the entire litter and for their mother, who now lives happily on a farm.

My sister, who brings her own dogs to that animal hospital, sent me pictures of the puppies, and I knew instantly that one of them would be mine. My sister picked up Clark to take care of him until I could fly down to get him, and she also took home his brother Toby, the last male left without a home.

In our family, all the pets are named after candy. Clark is named after the Clark Bar. (Toby is short for Toblerone). I knew Clark was special when, at just ten weeks old, he did not cry or have any accidents during the three-and-a-half-hour plane ride back to Boston. Despite protocol, his amazing temperament persuaded the flight attendants to allow him to spend the flight on my lap.

Clark is cuddly and social. He likes to spend his weekends at the dog park, the beach, or on playdates with other dogs. He also loves to go camping. Clark has very expressive and somewhat goofy ears. You can always tell how he's feeling by his ears.

Clark recognizes the sound of my car and waits by the window for me to come home from work. When he hears the car, he runs back and forth between the front door and the window until I walk in. His excited greetings make my day.

Bridget

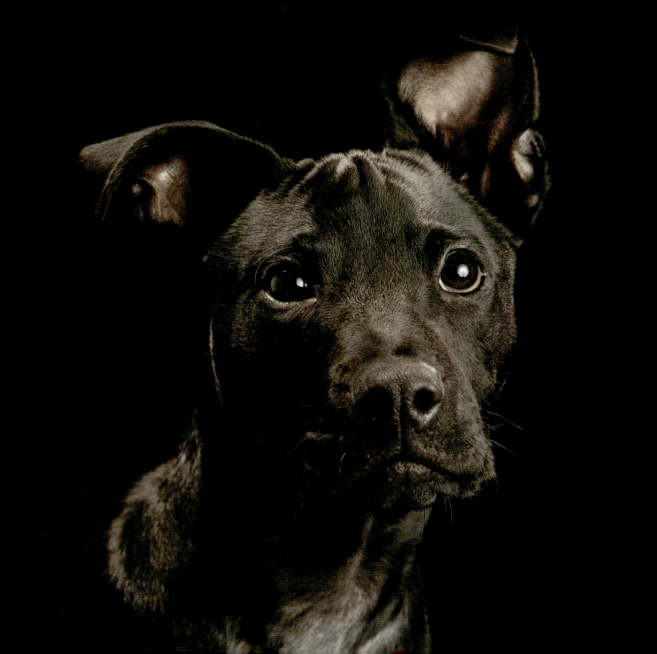

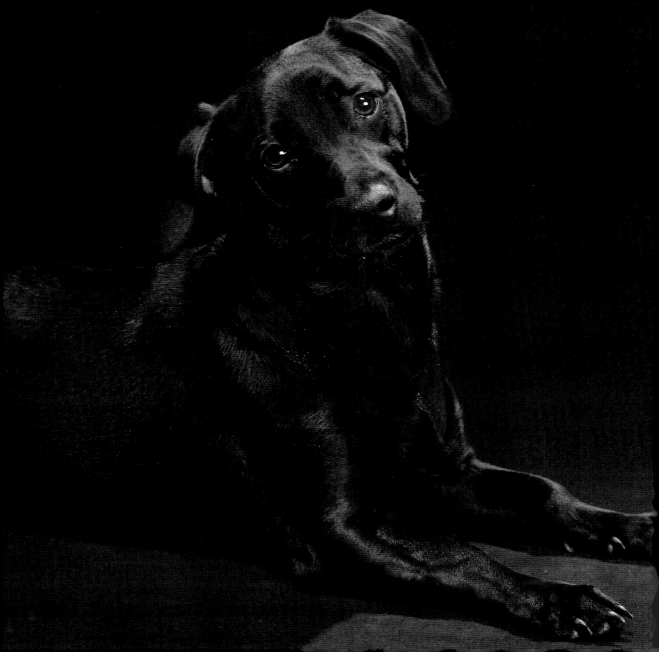

Lucy
Dachshund and Labrador Mix

We adopted Lucy from the Animal Welfare League of Arlington in Virginia. Though she was only ten weeks old when we met her, Lucy had already been in three shelters and had three different names. She and her sister were the only two puppies left from their litter that hadn't been adopted. When we walked in to meet them, they came rushing up to us, sliding across the floor. They still hadn't figured out how to use their tiny puppy legs. They both greeted us with a quick tinkle and wagging tails. Lucy, the bigger of the two sisters, was just the cutest little black puppy we'd ever seen. She was a little black ball with shining eyes and the whitest little teeth. She was barely a half inch (1.25 cm) off the ground and so soft. We instantly wanted to pick her up and hold her. She christened us with a good tinkle right away.

It was nearly impossible to choose which puppy to take home. Fortunately, Lucy helped us choose. As we were leaving, Lucy waited at the door, making perfect eye contact the whole while. Then, just before the door closed, she tilted her head slightly to the right, almost to say, "Can I go, too?" We were in love.

Since bringing Lucy home to Boston, we think she appreciates the constant supply of new toys and the endless amounts of peanut butter, but mostly our undying love. She enjoys morning coffee/cuddle time, trips to the dog park, and endless kisses and licks. She always sits with her right leg kicked out to the side; we call it her "kickstand," but it makes her look a bit like a pinup girl. We find it to be very endearing.

Lucy loves dogs and people without exception, and she manages to make everyone fall in love with her, too. We thank our lucky stars every day for our little nugget.

Whitney and Fritz

Frida
Mini Dachshund

Frida came to us via the Northeast Animal Shelter in Salem, Massachusetts. I was volunteering at the shelter every Friday morning, and one morning, there she was, sitting in her kennel and staring at me. For a very long time, my husband had wanted to get a mini dachshund, and as soon as I saw her, I called him to tell him about her.

We knew Frida was meant to become part of our family when we learned that she came from Puerto Rico, just like my husband and me. Her original name was Percy, but we changed it to Frida Flor del Rosario. She was named after the Mexican artist Frida Kahlo; Aibonito, her hometown in Puerto Rico, known for beautiful flowers; and my mother, Rosario.

We bonded instantaneously. Less than an hour after we adopted her, if I would walk away from her, she would cry. She knew she had found her forever family, and she wanted us to know it!

Frida's cutest quirk is her right ear that stands out to the side like an antenna. That ear has won her the Best Ears title for two years in a row at Cape Cod's annual Doxie Day. We spend a lot of time together, and if I'm in the room with other people, she begs me to pick her up to make sure they know that she is the center of my life—which she is!

Like the artist Frida Kahlo, Frida Flor del Rosario is feisty and determined, and also sometimes limps due to a hip injury she sustained before we adopted her. She underwent hip surgery and bravely recovered like a true champion—a few hours after the surgery, she was trying to run on three legs!

Frida is bilingual and responds to commands in English and Spanish. Like her mom, she loves to travel, always ready to jump into her carry-on bag and take off. Like her dad, she loves running and the beach.

We are grateful to Frida for making our lives a truly enjoyable adventure.

Dharma

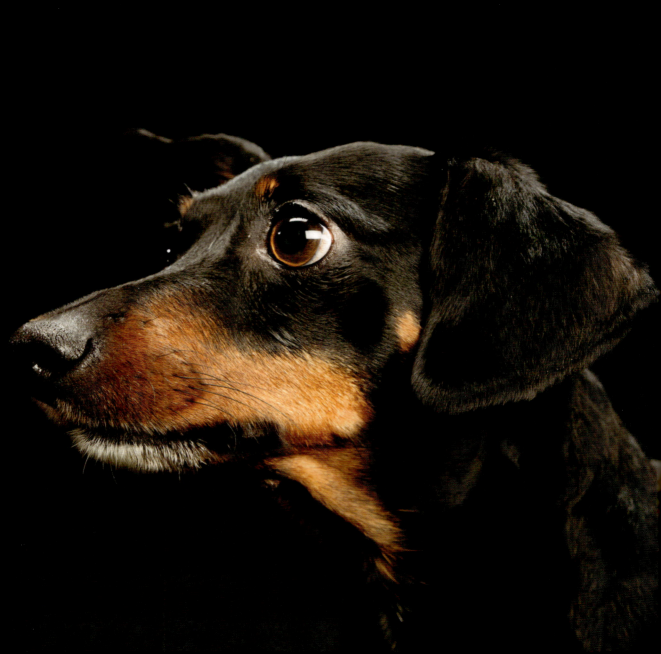

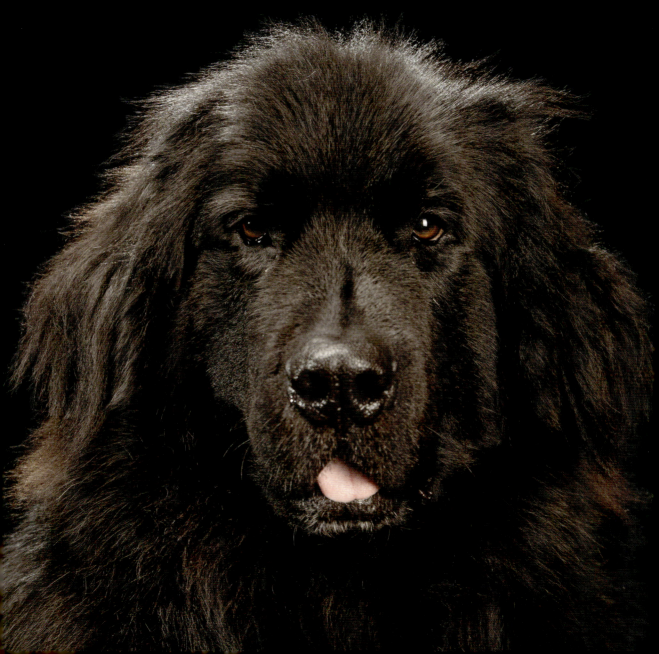

Blackberry
Newfoundland

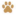

Blackberry came to us through Newfoundland Rescue when he was seven months old. He had been living in foster care, and before that, he had a loving home but his owner had to give him up due to an illness.

Blackberry has several endearing quirks. When it's time for us to take him for a walk or a drive, he takes the leash in his mouth and prances down the hallway. But the cutest quirk is something that we don't completely understand. He will be sleeping, or just sitting with us, and will suddenly go over to his bed, take his fleece mat in his mouth, and bring it onto the floor. He then cradles it in his front paws and rhythmically nibbles it. Every minute or so, he will jerk his head and then continue to nibble. He is totally in another world when he is doing all this—as if he's in a daze. Another quirk of Blackberry's is his obsession with shadows. He will chase them and bark at them and pounce on them.

We feel a lot of love coming to us from Blackberry. He is very content and confident. He would rather be with us than anyplace else. He sits between us on the couch and likes to snuggle, and he loves to go for car rides. We knew how special he was when we were walking him downtown and we saw a woman in a wheelchair. She was unable to speak. Blackberry went up to her, looked at her face, and licked her. She seemed very touched by this.

Blackberry is very affectionate toward people he meets and is good with children. He is quite large and beautiful, and people are drawn to him.

Beth and Charles

Maggie
Dachshund

I have always had dachshunds and had recently lost a beloved ten-year-old doxie named Molasses when Maggie came into my life. My daughter saw Maggie in a pet store window and fell in love with her. Despite my strictures about not getting dogs from pet stores, she bought her and brought her home to me. I couldn't refuse, and it turned out, in fact, that we had indeed rescued her.

Maggie was a puppy mill dog and had had a horrible beginning. Shortly after we got her, she came down with mange, which the vet told us is common in dogs from puppy mills. She had not been properly socialized and had so much to overcome.

But she was loving and adorable. Those big brown eyes are hard to resist! She had to be fed by hand for the first few weeks—something she did indeed overcome! Maggie is one of the world's best eaters. There isn't a food (or even a nonfood) that she rejects.

Recently, at age sixteen, Maggie had a severe attack of pancreatitis. She had a fever of 104.7°F (40°C). I was sure that she was dying and I took her to the vet, wrapped in her favorite blanket, expecting not to return with her. She couldn't stand and was lying on the table. Then the vet put a biscuit in front of her, and she reached out and took it! The vet said she was a fighter—an "excellent little beast"—and she wasn't ready to go. Miraculously, she's now back to her normal self.

At sixteen, Maggie's vision is imperfect, her hearing is (selectively) deficient, her sense of smell is weak—and she's a happy dog. She greets me with a tail wag every time I come home. I would never buy a dog from a pet store again, because I do not wish to support puppy mills, with all their cruelty and abuse. But I am so glad we were able to give Maggie a good, loving home, and the best life a dachshund could have.

Beverly

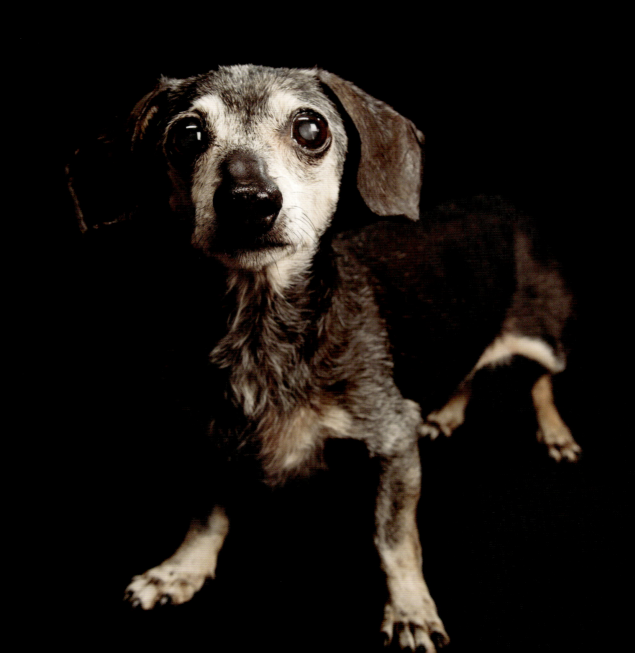

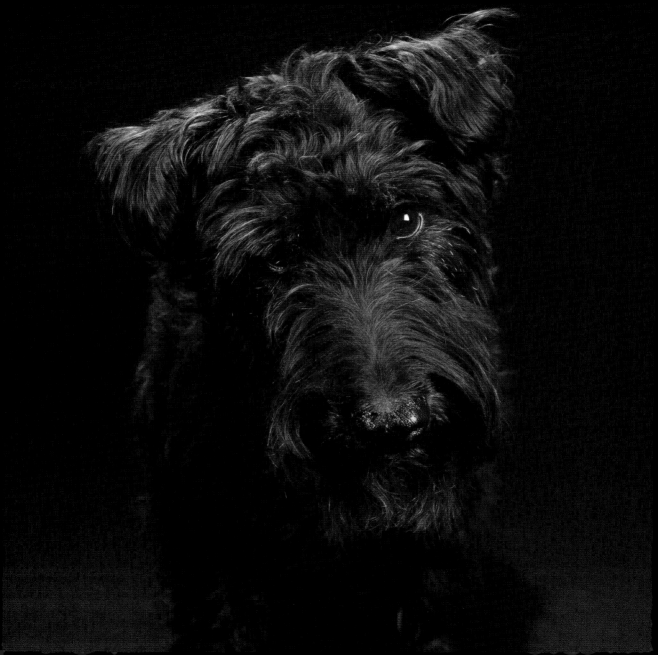

Fenway
Scottish Terrier and Poodle Mix

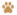

When I turned twenty-five while living in Colorado, I decided it was time to get a puppy. I grew up in New England with a Scottish terrier named Katie. Katie was a great dog, so I knew I wanted a Scottie of my own someday.

When I first met Fenway, I thought he was the cutest thing I had ever seen, with a tiny body and giant head. The word "cute" quickly grew into a more fitting adjective: handsome. He was a handsome boy, or "rascal," as I used to call him.

For nine years, I was fortunate to tell Fenway he was handsome on a daily basis. He had so much personality in his face; his eyes could tell a story. He knew the rules at each house he visited and greeted all dogs and owners we passed on our daily walks.

I used to call Fenway the "mayor," as he would sit on his ottoman in front of the window, keeping an eye on the street. He was well known on the streets of our neighborhood in South Boston. Fenway wasn't much of a walker—he hopped. I used to refer to his feet as "happy feet," and sometimes they would move so fast, he'd just lose his footing and fall over.

Fenway loved to snuggle. If you were on the couch, he needed to be right there next to you. Every night for nine years, Fenway would grab his favorite toy, a blue hippo named Blue, and carry him to bed. When Fenway passed unexpectedly on March 16, 2015, I found comfort in Blue as Fenway did, but I knew in my heart that Blue needed to be with Fenway. Two days after Fenway passed, I drove Blue over to the vet to be with Fenway for eternity.

As much as we hope and pray, dogs can't live forever, and when they pass, a piece of you goes with them. I know wherever Fenway is, he's snuggling with Blue and hopping all around, greeting all the other dogs—and chasing after cats—with the biggest smile on his face.

Lauren

Bruin
Puli

We had lost our first puli, Buda, only three and a half months before being lucky enough to welcome Bruin into our family. At first, I didn't know how long it would take for me to recover from losing Buda and to be able to welcome a new dog into our lives.

As chance would have it, the first breeder I contacted was the breeder of one of Buda's relatives, so we connected instantly. She happened to have a litter due the next week, and Bruin still needed a home.

Bruin started his life with us on the hours-long car trip home from New York, spending the entire ride cuddling and wiggling on my daughter's lap. Bruin's instant affection for—and loyalty to—our daughter certainly didn't replace her loss of Buda, but it helped her know that she could welcome and love this new pup.

From day one, Bruin has had a big personality. In the mornings, he bolts out of his crate in sheer exuberance, spins a fast U-turn, and then jumps up to get his morning rubs and cuddles. He also can't wait to melt into whoever is sitting on the living room love seat to watch television.

Bruin's cutest quirk may also be his most annoying! As soon as someone comes home, or passes him, and offers him some loving words, pats, or cuddles, he takes off to find a toy and invites us to play "Tug-Tug" with him. It's hard to resist the invitation, especially with his big brown eyes staring pleadingly.

Bruin lives with four cats, his favorite being our tough little calico. Bruin taught her to wrestle like a dog when she was just a tiny kitten. Now, she usually gets the better of him in their bouts.

It turns out you can never replace a loved and lost dog, but there is plenty of room in your heart to welcome a new one. Bruin immediately felt like a new member of the family the first moment he was placed in my daughter's arms.

Alyson

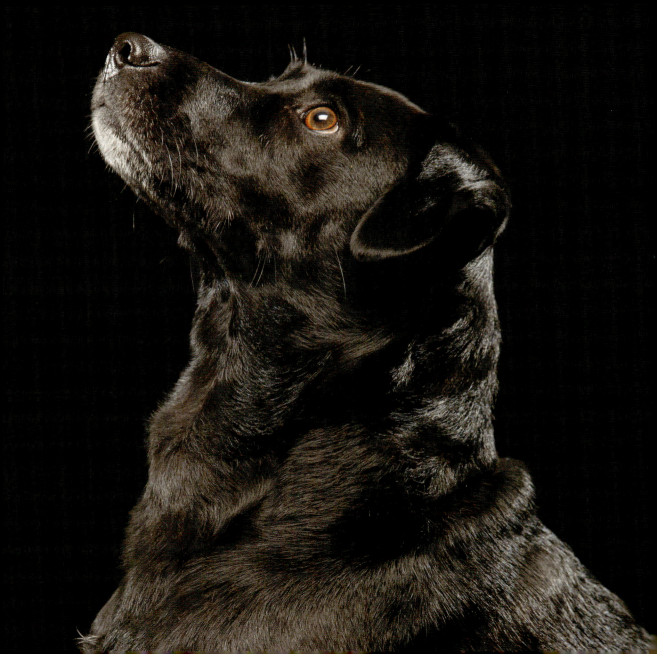

Daisy
Labrador Mix

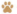

When I first met Daisy, I knew she was the dog for us. She was playful, cute, and sweet. She was so excited when I came into the room that she jumped up onto the counter. It was amazing!

We adopted Daisy from a local SPCA. We had been planning to adopt a different dog, but due to that dog's issues, her foster family decided it would be best to keep her rather than rehome her. They told us about Daisy, and when I went in to meet her, I immediately fell in love!

Daisy had a sad life before coming to us. She had at least two owners before us in her young life. She had been sold online to the people who had her before us. That family kept her for six months before dropping her at the shelter and naming allergies as their reason for surrendering her. Her fear of certain dog breeds and her fear of most men led us to suspect that she suffered abuse and that she may have been involved in fighting, or perhaps had been living with aggressive dogs.

When Daisy first came home, I think she most appreciated having a family who loved her and being able to snuggle in bed with us! She wants to be with us at all times. Sometimes it can be difficult, but it's sweet that she just wants to know we're there.

Daisy is so wonderful with our daughter. We weren't sure how she'd be when our daughter was born, but they have become the best of friends, and I know that Daisy would do everything in her power to protect her.

Sarah

Bodhi
Labrador Mix

In 2005, we had two young sons and one very old kitty. After our cat passed away, we began flirting with the idea of getting a dog. We are proponents of adopting animals. We love the feeling of freeing an animal from a cage and giving it a home.

Searching online, we learned that many rescued dogs in the Boston area, where we live, are brought from the South, usually taken from high-kill shelters. Bodhi's mother was pregnant and in such a shelter when she was rescued. Her litter of ten black Lab mixes was born at a foster home.

We liked the look of one little guy from the litter and sent in our application. After a thorough vetting process, we were finally handed one tired and very dirty puppy. It was one of the best days I can remember.

Bodhi is an amazing dog. He is gentle and playful, and he loves to swim. He will pick up his leash and walk himself down the street. He likes all the people in the neighborhood and nearly all of the dogs. He's getting up there in age and doesn't move as quickly, but he still thinks and acts like a puppy, and we're happy about that.

Our kids joke that all our animals look the same—dog or cat, they are all black with long, shaggy hair. We will probably always have black pets in our home, and they will all come from rescue organizations.

Laurel

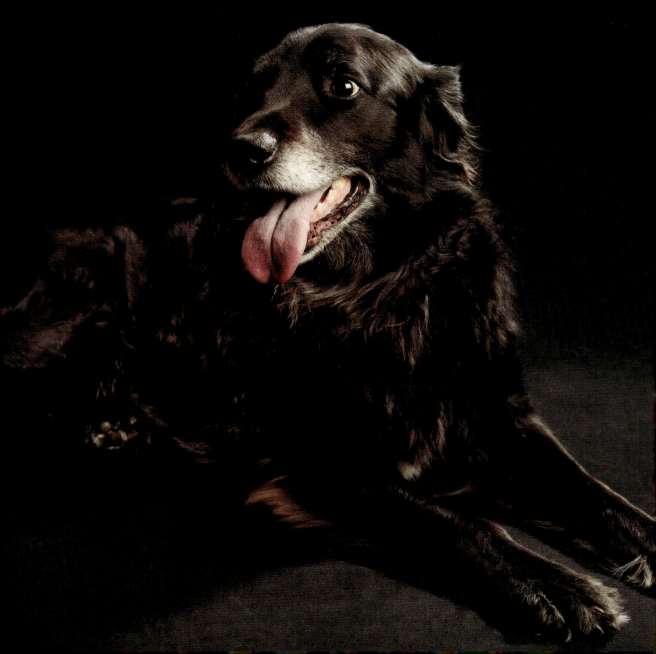

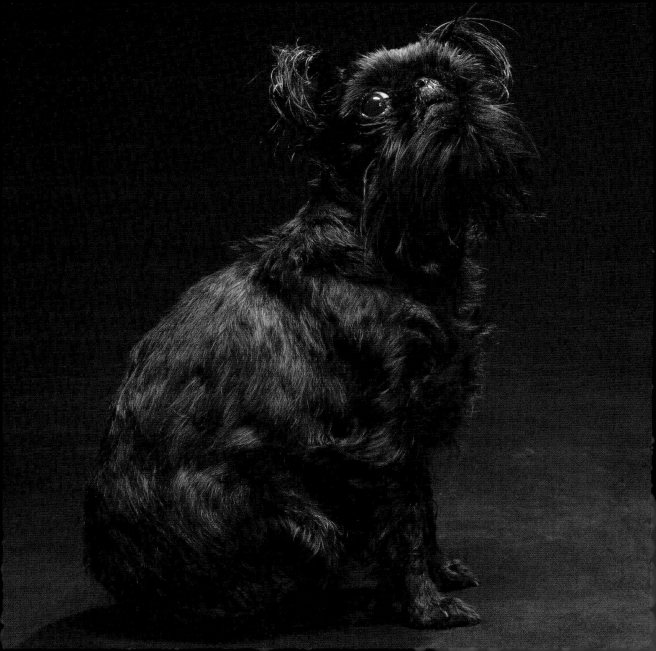

Day-Z
Brussels Griffon

When Day-Z first came to us from the breeder, she weighed only two pounds (just under 1 kg). A funny thing: she was often mistaken for a cat by people who met her because she had little elfin cropped ears (which are now disguised by her ponytail-styled hair)!

When we get home from work, Day-Z spins in circles, and when she's really happy and being silly, she digs on the couch and rubs her head on the cushions. Her best (dog) friend is Casper, a silver Labrador. They truly are besties and enjoy frolicking together, even with their significant size difference.

If Daze Craze (our silly nickname for her) were human, she would be a princess. How could she not be? She's waited on hand and foot and enjoys traveling everywhere in her "durse" (dog purse)!

Paula and Patrick

Lexi
Labrador Mix

While anticipating Lexi's arrival in my life, I was ecstatic but also very nervous. Knowing that she was a dog who already had an intense history at such a young age, I was anxious about whether bringing this dog into my life was the right decision. When I first saw her face in person, I knew she needed to be loved and to come home with me.

I was Lexi's third owner by the time she was five months old. She was born in North Carolina, where she was taken in by a family, but shortly after, they had to give her to a shelter because of landlord issues. She was then brought to Massachusetts in a truck, with nine other dogs, to live with a couple who had turned their home into a shelter. Lexi was quickly adopted by a young family, but they returned her in less than a week because she was such a handful.

Lexi is the best cuddler. She's playful yet protective and full of personality. I think that she most appreciated being given unconditional love when she first came to my home, and she appreciated that she was trusted and was not going to be given up on again. Lexi has a few neuroses. At every meal, she takes the first piece of kibble out of the bowl and brings it to the rug under the kitchen table, eats it, and then goes back and finishes the remainder of the meal. When she lies down, she sprawls her legs out like a frog, and when she gets off the couch, she slides off like an otter!

Even though she had been abandoned by two families, Lexi still gave me the chance to come into her life. She trusts me and loves me unconditionally.

Liza

Teddy
Labrador

Like many of the best things in life, Ted came to us by accident. We had recently rescued a middle-aged Lab who had been abused and was going through separation anxiety. Lab Rescue suggested that another puppy might be just the cure for the older dog.

Ted just loved being part of the family. He made a point of greeting every family member and making each one feel so loved. Whether someone was a little chilly and needed a ninety-pound (41 kg) warm Lab to sit on their lap, or was a little lonely and could use a hug, Ted seemed to know and embraced the chance to build a stronger relationship.

Ted could never get enough of retrieving a ball. He also had a knack for finding a swimming hole whenever there was one around. He would jog excitedly into the water and start to float, and then swim around and look back at us with a big smile. He showed us that it is the little things in life that make us happy.

We had Ted certified to be a therapy dog, and we brought him to nursing and rehabilitation centers, where he greeted patients warmly with a tail wag. One time, we dressed him up as a ballerina princess for a nursing home party, and he bravely wore a pink tutu and fairy wings!

When we adopted our third child, Phoebe, Ted was about ten months old. Our daughter came from a rural orphanage across the world and had no knowledge of dogs. In a short time, the two developed a mutual appreciation. Phoebe discovered that Ted was fun to play with, and Ted discovered that lurking below Pheobe's high chair would reward him with a shower of tasty morsels.

Ted died recently and we buried him under a large rock in the backyard surrounded by black-eyed Susans. Ted transcended being our dog: he was our best friend and the dog of our children's childhood. I'm so thankful to have had Ted in our family.

Amy and Dan

Beau
Labrador Mix

Beau came into our lives one morning in July 2014. We knew that he would become part of our family before we even met him. His virtual presence was compelling enough to reach out to us as we were looking through the adoptable animals on the Boston Animal Rescue League's website.

We had been considering adopting another dog after the loss of our beloved Rocco, another black senior from a shelter, but we felt unprepared and unable to open our hearts to another dog. This changed when we first saw Beau. We forgot our plans for a leisurely summer day and drove straight down to the Animal Rescue League in Boston.

Beau is blind but that did not stop him from climbing up onto the couch that we were sitting on during the interview process. When we brought him home, despite the fact that we had bought him two new beds, Beau claimed the couches with a confidence and ease that showed us that he knew he was in his forever home.

By the time the Animal Rescue League had taken him in, his eyes were so painful with glaucoma and cataracts that the only option was for him to undergo a bilateral enucleation. Despite the loss of his eyes, and any other deprivations that he may have suffered, Beau is not defined by his history. His resilience and capacity for love make this boy the special dog that he is.

Beau gets excited when he meets anyone. He does not judge humankind by any negative experiences that he might have had in the past.

Beau shows us his love through all the trust that he places in us each day. The first time we took him up the flight of stairs in our house, he was relying on us to be his eyes. His faith in us is unwavering and humbling. Every evening when Beau jumps up into our laps to claim a sleeping spot—and pretend he is a sixty-eight-pound (31 kg) lapdog—he shows us that he knows he is finally with his family.

Catherine

Sam, Newfoundland

Patrick
Toy Poodle

When we first met Patrick, he had a show haircut and looked like a lion—we were in love! He was named Patrick because he was born on St. Patrick's Day, and his show name was Kissing the Blarney Stone.

We purchased Patrick from a breeder who had purchased him from another breeder when he was four months old. At eight months, the breeder decided not to keep him in her program because he was too oversized to show. We gladly became his third and final owners.

Patrick jumped into our laps when we first met him. When we brought him home, he loved the individual attention he received from us and knew he was staying and getting spoiled, with his own bed, the run of the house, and his own toys.

Patrick follows us everywhere. He waits for us when we are getting ready to do anything. He lies on our laps and sleeps for hours. He kisses us, and when we pull away, he puts his paw on our faces so he can continue to kiss us. He nuzzles next to us in bed or on the couch.

Patrick's cutest quirk is prancing around while carrying his things to keep them safe from his new "brother," Cayman. He also cocks his head when you talk to him. He amuses himself by playing ball, chewing bully sticks or rawhide, and shaking his stuffed animals.

Patrick became a "big brother" five months after he arrived. Cayman is a brown, oversized toy poodle whose personality is the complete opposite of Patrick's. Although he likes to chill out, Patrick has shown great restraint with Cayman—a puppy who has trouble sharing and never slows down.

Patrick loves attention and being held. He always jumps up to greet people and tries to kiss them. He approaches dogs no matter their size and always wants to play with them. Although he doesn't initiate kissing Cayman, Patrick responds by licking him back. He knows he is loved and is a wonderful companion.

Maddie and Marilyn

Mercedes Ann
Standard Poodle

I fell in love with Mercedes Ann the moment I picked her up. As a puppy, she put her paws on my shoulders and gave me a hug, and the rest is history.

Mercedes has always been willing to learn. Even now, at the age of seven, she continues to master new tricks. She's always up for an adventure, no matter how difficult the circumstances.

At only a year old, Mercedes became a certified therapy dog with Pets & People Foundation. Twice a week, she visits with patients at a local hospital, and she makes hospice visits on a regular basis. She also has participated in many stress-relief events at high schools and universities.

Mercedes constantly amazes me with her unbelievable compassion and kindness. She always knows when someone needs that extra bit of affection, even if that someone is me.

Christine

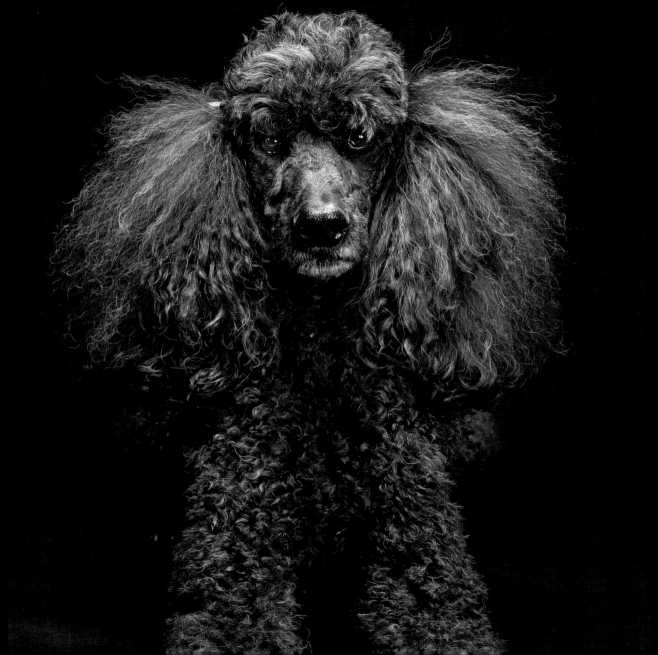

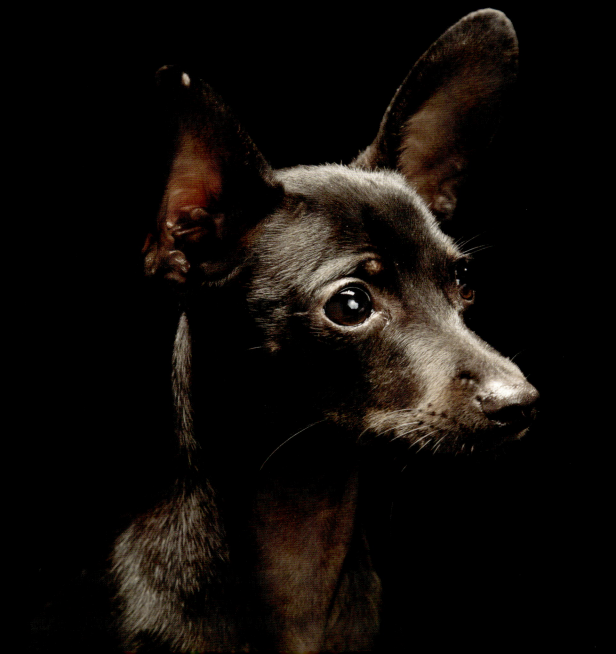

Oscar
Chihuahua and Miniature Pinscher Mix

The feeling I had when I first saw Oscar is hard to describe. I had been looking to add a puppy to my family for a while, and seeing him was love at first sight. He was adopted from a couple who could no longer take care of him. They had no time for him, and he would be alone all day at three months old. My partner works mostly from home, so we had all the time for him, and they chose us to be his parents.

Oscar showed so much curiosity and energy when we first brought him home, and we loved that. He throws a party when we come home, as if he has not seen us in ages! He gives us millions of kisses and licks, and he loves to cuddle with us when we watch television rather than lying in his bed alone.

Feisty but super sweet, Oscar has so many quirks! When he wants our attention, he sits and puts his ears back and makes a little talking noise—it's a mix between a growl, a cry, and a bark. With adults, he barks at them first, but then likes to be picked up. With kids and other dogs and cats, he loves to go up to them and initiate play. He especially loves bigger dogs, even though he is only five pounds (2 kg).

The first time I saw Oscar's photo before getting him, he just had this look that I had never seen before, and I thought, "He is for me!"

Julieth

Abby
Labrador

We found our Abby girl at Baypath Humane Society in Hopkinton, Massachusetts. My husband and I had just bought our first home and my father came to visit. He knew that one of the first things we wanted to do when we bought a house was to get a dog to make our house a home. So we went for a visit to local shelters. It was like when you go shopping for your wedding dress—usually the first one you try on is the one.

Well, Baypath was the first shelter we visited, and Abby was the one. We saw her in the yard and asked if we could take her for a walk. She was so cute, but thin. My dad knew we wanted her to come home with us, so he wrote the check and gave us the best housewarming gift ever.

Abby was about a year and a half old when we adopted her, and she is almost fourteen years old in this photograph. She has the most soulful eyes. All we have to do is look into them and we know what she's saying to us. She sleeps with us every night and takes turns snuggling with my husband and me.

For the past several years, my husband and I have been volunteering for the Save A Dog shelter in Sudbury, Massachusetts. Every Tuesday night, we close up the shelter and let the dogs out one last time before tucking them in for the night. And every Tuesday we say to Abby, "Abby, do you want to go for a ride to Save A Dog?" And it's like she knows when it's Tuesday because she waits expectantly for us to ask her the question. She answers by jumping up and down excitedly. She waits in the car for us as we go into the shelter to do our duties, and we all drive home together with smiling hearts.

Andrea and Bob

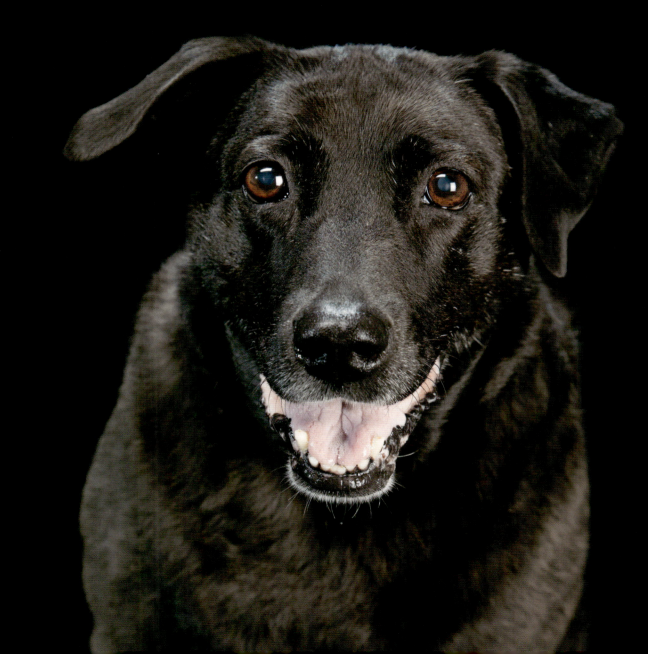

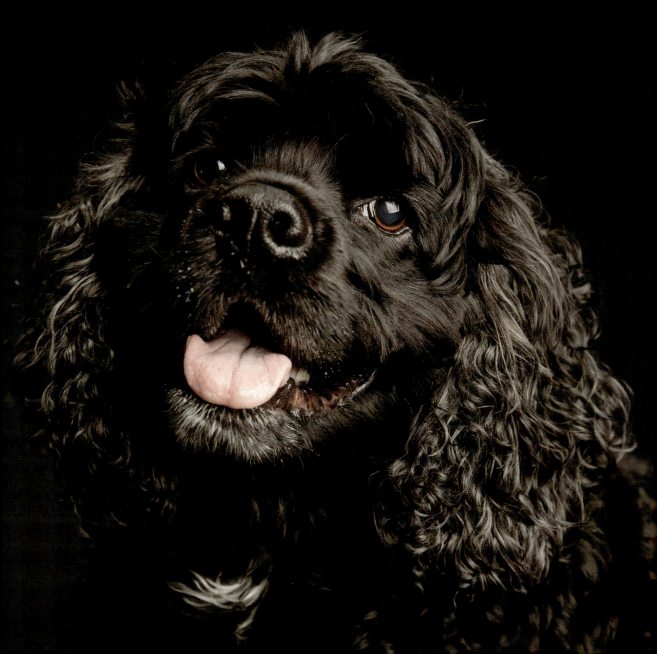

Duncan
Cocker Spaniel

I met Duncan on a winter day more than eight years ago, and it was love at first sight. There were many adorable dogs available, but I only had eyes for the sweet-looking black cocker spaniel. He was calm and relaxed as I rubbed his belly.

I didn't bring Duncan home right away. I traveled to India for two weeks for work and could not stop thinking about him. I had never felt that way about any animal before; it was an immediate connection, and I needed him in my life.

I was still grieving the sudden loss of my father, and Duncan was a loving comfort to me. I even named him after the navy destroyer ship my father was on during the Vietnam War, the *USS Duncan*.

Duncan loves his family and the constant love and attention he receives from me, my husband, his Nannie (my mother), and our extended family. He loves his walks and running free to roll and play. He never goes too far, always making sure he has us in his sight. He loves his weekly Saturday morning swim at an indoor, heated therapy pool specially designed for dogs.

Although Duncan is very playful, he is an old soul. Duncan is very sweet with children of all ages. He has spent a lot of time with all of our nieces and nephews, and when I speak to the kids on the phone, they always ask, "What is Duncan doing?" Duncan celebrates every occasion with us, sitting at our feet as my husband and I exchanged vows on our wedding day.

Duncan will play for hours, bringing you his ball or squeaky animals to throw. He loves unwrapping his gifts at Christmas and his birthday. In the morning when we wake up, there are many toys and bones throughout the room; it's like having a toddler in the house, and we love it!

Duncan is a gentle, sweet, fun, cuddly dog, with a loving soul. I cherish every moment I have with him.

Christina

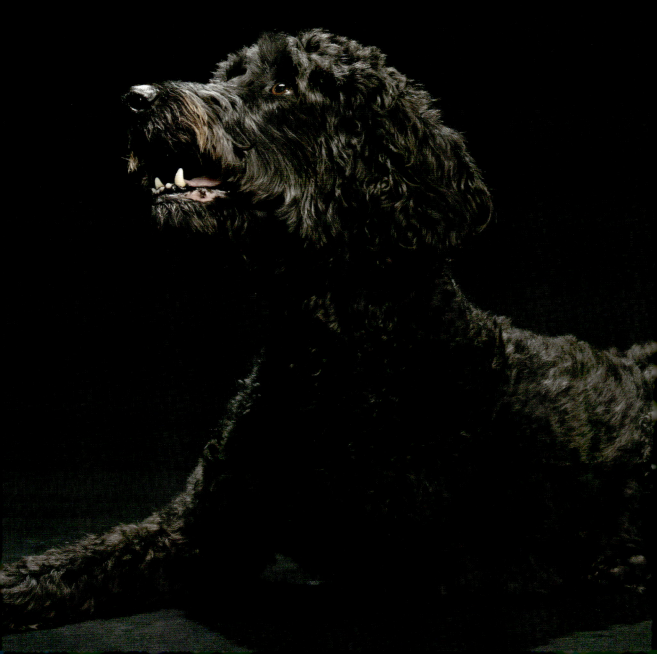

Sophie
Labradoodle

It was never my intention to leave the animal shelter with a large dog. Sophie, a year old when I met her, weighed thirty-seven pounds (17 kg). Stitches, from an accident that took her left front leg, had just been removed. Sophie had never slept in a shelter, and that night seven years ago would have been her first.

Sophie gained an additional twenty-three pounds (10 kg) in the weeks after her adoption. Over the next few months her personality really came out, and I was excited to learn that she was a happy, affectionate, and outgoing dog. She adores people and loves to be near other animals. Sophie is totally secure in herself, and she's quite athletic! She has boundless energy and determination.

Sophie's strength and enthusiasm for life make her great fun to be around. People are awed and humbled by her speed and strength. Most importantly, they are inspired by Sophie's exuberance and zest for life. She's a black dog with an important message.

Nancy

Emmi
Labrador Mix

When we first saw Emmi, I knew that she would be the one for me. Several months earlier, I had unexpectedly lost my six-year-old Lab mix to an aggressive cancer, and there was a hole in my heart the size of the Grand Canyon. I saw Emmi and I immediately felt that hole getting a little smaller. She looked so sweet, little, and innocent that I was almost afraid to hold her.

Emmi had the look that we always referred to as the "love me, love me, love me" Lab look: the long, floppy ears, the searching brown eyes, and a sweeping tail. She was affectionate and followed me around everywhere. While I don't know her entire story, I suspect that Emmi and her littermates had been left by the side of the road or at a highway rest stop. Eleven years later, Emmi is still afraid of roads and cars.

When we brought Emmi home from the shelter, I think what she appreciated most was feeling safe. When we got home, she immediately ran into her crate and lay down. During the first week, any food or treat or toy we would give her, she would take back into the crate as if to say, "It's mine! I don't have to share with the other dogs anymore!"

On walks, whenever we see someone who is physically disabled, Emmi will approach the person and stretch taller or crouch down to get petted. From her earliest days with us, she fed off of human attention. As my dad became sicker, Emmi became more sedate, watchful, and attentive around him. It was shortly after my dad passed away that I realized I had to share Emmi's talents as a therapy dog, and we got certified together as a therapy dog team.

Emmi senses those whom she thinks might need a nuzzle. Her weekly visits to nursing homes and congregate living facilities have her as the center of attention. Somehow she knows just what the person needs, far better than I do. She makes me a better person every day.

Laurie

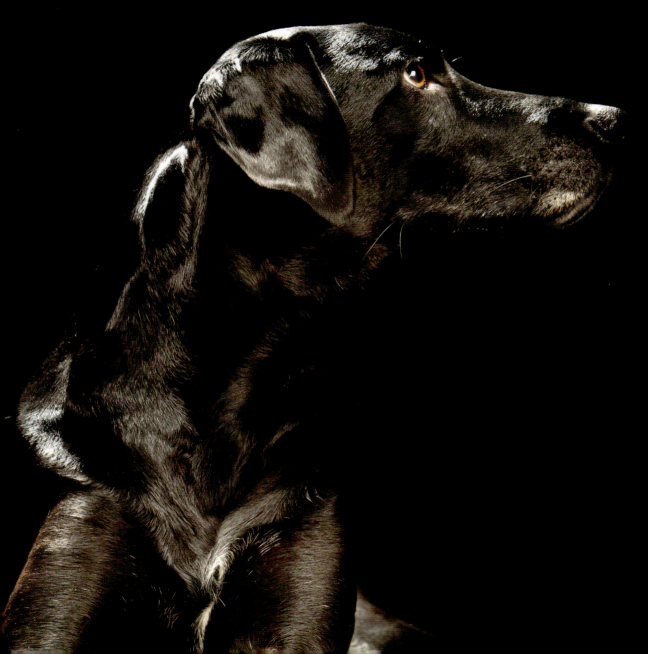

Chet
Mixed Breed

The second I laid eyes on Chet, I was determined to take him home. He had been at Northeast Animal Shelter—a no-kill shelter in Salem, Massachusetts—for just one day, and the thought of leaving him there any longer broke my heart.

Chet had been fostered in Indiana for a month, but where he was prior to that is anybody's guess. His sleek black coat, food aggression, and love of burrowing led us to suspect that he was a former Puerto Rican street dog.

Chet barely stayed put long enough to be petted, and just as I began to say, "At least he's quiet," he let out a howl. Simply put, he was twenty pounds (9 kg) of pure insanity. I came back the next night with all of the required paperwork, and the rest, as they say, is history.

When we brought Chet home, he immediately sprinted upstairs and did his business all over the carpet. Months later, Chet showed minimal signs of settling down. My friends raised their eyebrows and held their breath; my fiancé, Joey, likely considered running away and never coming back.

Now, more than four years later, we couldn't possibly imagine life without Chet. Yes, he has his quirks. He sprints downstairs three paws at a time. Every morning, he lets himself in the bathroom the second the shower shuts off and leads me to his bowl with great urgency. Oh, and he thinks the people that live in the condo upstairs are one day going to kill us.

Regardless, Chet loves us without abandon. He wraps his little paws around our necks and kisses us until we can't breathe. He acts like we've returned from three tours of active duty when we come home from work each day. He paws at us to make room for him to nestle into our laps, sighing deeply if we dare to move.

There is no one in this entire world who loves you as much as your dog does. Dogs love differently, loyally, and unconditionally. They never let anything else get in the way of that.

Michelle

Pinto
Mixed Breed

It's cliché, but it's true—you know he's your dog the minute you meet him. Pinto, all thirty-five pounds (16 kg) of pure wiggly energy, had been sitting in the back of his pen, not interacting. The second I walked over, Pinto pressed himself up against the wire door, tail wagging like crazy, just waiting for me to reach through. It was love at first sight, or rather, first lick.

Pinto was a rescue from the Chicago Anti-Cruelty Society. Despite many previous visits, I had never quite clicked with any of the dogs. My boyfriend and I were downtown that day and stopped by for a quick visit. When we got to Pinto, he was just so sweet and playful, with beautiful black-brown eyes pleading with us to take him out. We obliged, and after vigorous rounds of tug-of-war, belly rubs, and endless kisses, I knew that I couldn't leave without him.

Pinto was such a huge part of my life; I started and finished every day with him. He had such a joy for life, and he loved to share it with everyone. And then the kisses! Pinto was never stingy with his kisses. But most importantly, Pinto just understood and knew exactly how you felt.

My favorite little quirk of Pinto's was his singing and whining ability. Pinto would let you know he was disgruntled through his incredibly persistent, almost operatic vocals. Standing still too long? Dog friend not walking toward him fast enough? Maybe he was just SO EXCITED about all the new smells at the vet's office? As he yodeled with a smile, I could have sworn that Pinto was almost able to form words and speak to me.

As a shelter dog, Pinto was a bit anxious at first, but he quickly figured out that I wasn't going anywhere— not without him! Sadly, after more than ten glorious years together, I had to say good-bye to this furry piece of my heart. Pinto made me a better person and immeasurably brightened up my life. I love and miss you, beany bear.

Jenny

Kenai
German Shepherd

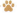

When she was a puppy, Kenai was a round bundle of fluffy fur. The breeder told me the long fur was not what show dogs should have. But who would be able to resist the cuteness? Besides, she was not meant to be a show dog.

Kenai was the feistiest and the fluffiest black shepherd in her litter. We wanted an all-black shepherd who had been bred by a breeder who truly believed in preserving the health and welfare of the bloodlines of the dog.

When we first brought Kenai home, she loved the treats and toys in her crate. She loved the hugs and cuddles from all of the kids at our farm. She also loved our bloodhound, Cinco. As she's now a bit older, she brings her toys over to me to remind me to get outside and exercise with her.

Now that we have a new puppy in the house, Kenai is the oldster. But she is incredibly cute when she plays ever so gently with the new pup while trying to look mean by baring those enormous white teeth.

Kenai is alert, dedicated, and fearless. I realize she is truly special every single moment I am with her.

Susan

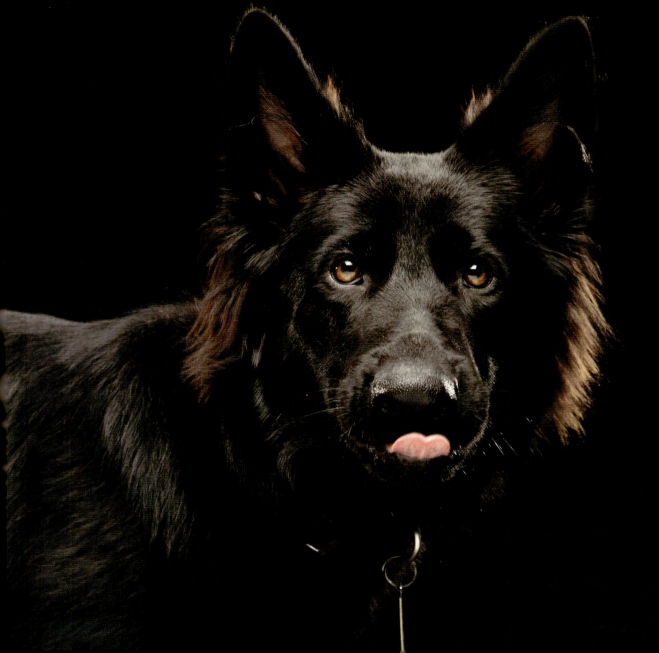

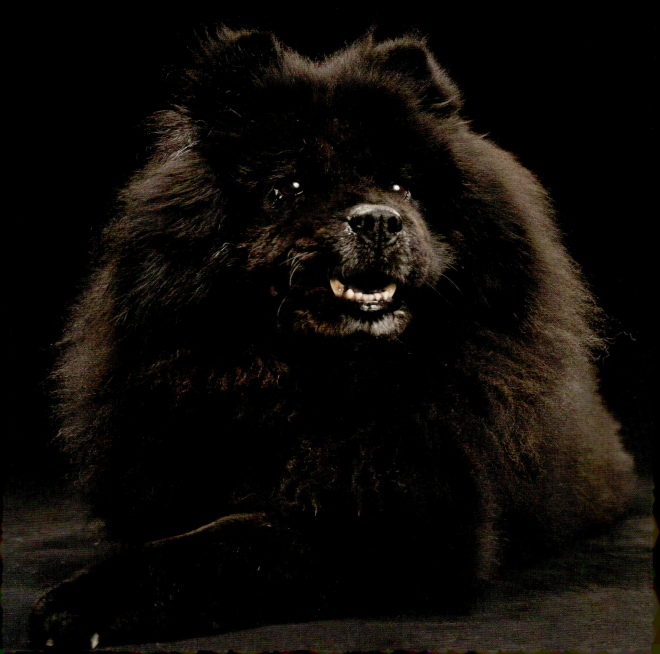

Lena
Chow Chow

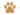

When Lena was rescued by the Pet Adoption League of New York, she was in deplorable condition. Matted and starving, with a tooth embedded in her gum (an injury determined by a vet to have been the result of a kick), she was in a depressive daze from her suffering.

After being vetted, she was placed with a loving foster dad who nurtured her for eight months while a permanent home was sought. Lena had two strikes against her: age (she was eight years old at the time) and color.

When I first met her, it was not love at first sight, on either side. More an ice queen than an icebreaker, she exhibited the typical chow reserve toward strangers and the equally typical, although understated, bond with her human, in this case her foster dad. I pondered the adoption for two weeks before going forward, considering it an interesting challenge. After paying little attention to me for the first month or so, Lena finally yielded to the pull of connection.

Lena represents the best of her breed: discerning, well-mannered and loving, with a strong and delightful sense of self. (Her dignity, let me be clear, is sometimes compromised by her predilection for sleeping under curtains; her snore, which sounds like an idling Harley; and her mischievous streak.)

I have now had Lena for three years. I, too, submitted to the pull of connection; I became hers, and remain so.

Elanah

Shadow
Mixed Breed

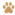

Shadow is a rescue dog who had been at Petco with his siblings for Save A Dog's adoption drive. As soon as I saw Shadow in the corner trying to sleep while his brother Tuffy was jumping all over him, I knew he was my perfect match.

The next day, I received a phone call saying I was chosen to be his mom. Since I brought him home, Shadow has been the complete opposite of what I originally anticipated! He loves to play and needs attention all the time. Since Shadow is so active, he has forced me to get back in shape and live a healthier life. Every day, we walk three to eight miles (5 to 13 km), and he has helped lower my cholesterol, a long-term issue of mine.

Shadow is a very affectionate dog, and he loves to cuddle. I think he appreciates that my younger brother adopted his brother, Tuffy. We wanted to adopt siblings so that they could grow up together and never be lonely. Shadow and Tuffy see each other weekly, and the day after spending time together, they don't leave their beds due to exhaustion from playing nonstop.

Every morning when Shadow hears my alarm go off, he jumps on top of me and kisses my face—his way of saying good morning. And every day when I return home from work, he greets me as if I have been gone for days, and then he does not leave my side the entire night. When I leave a shirt on the couch, he drags it to his bed and sleeps with it while I am at work. I always try to leave one of my shirts for him to cuddle with every day.

Shadow gives everyone kisses and loves playing with children. He's friendly and playful with most animals, but his archnemeses are squirrels! Shadow senses when I'm sad and comes over to cuddle with me as if he is saying, "Don't worry, Mom, everything is going to be okay." I am so glad that he is part of my life!

Angela

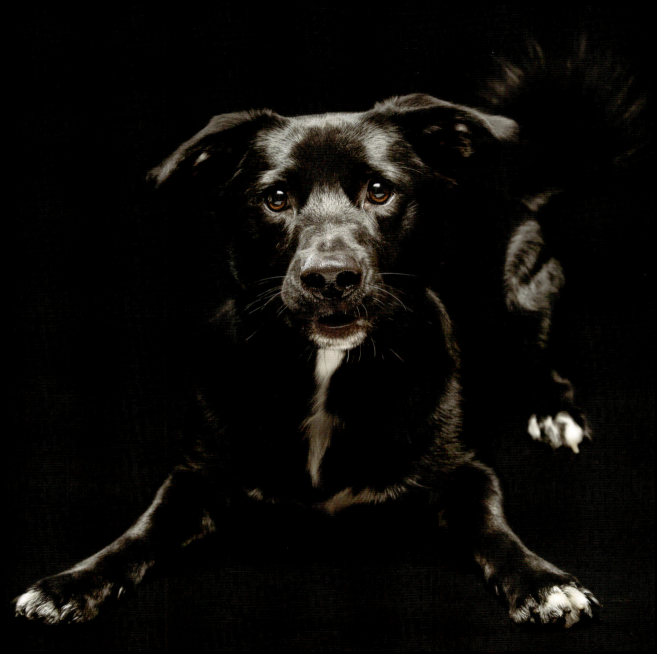

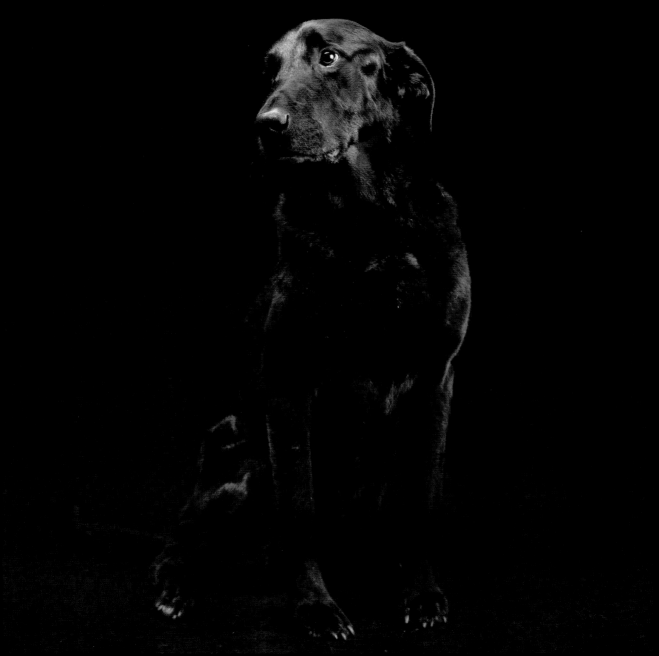

Max
Labrador

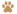

On a crisp fall day, Max's owners walked him into the Town of Hempstead Animal Shelter in New York to be euthanized. He was old, they said, and had separation anxiety and food-guarding issues. They just didn't want him anymore.

For months, Max languished in a kennel at the shelter, well taken care of but passed over time and time again because he was a senior black dog. Max became more and more depressed. The shelter, realizing what an amazing dog Max is, reached out to Hounds Town USA and enlisted the help of commercial dog trainer Michael Gould.

When Max first arrived at Hounds Town, where I work, he came bounding through the door, wagging his tail a mile a minute and greeting everyone with slobbery kisses. After a few days of training and evaluation, I was compelled to take Max home to see if he really had any of the behaviors his previous owners claimed he did.

For a month, Max and I did everything together: we went for walks, we worked on his separation anxiety, and we did errands together. I tried to stimulate his food guarding, to no avail. His response was to look at me with his big brown eyes, tail wagging feverishly, and sit patiently until I put his food down. I quickly realized his previous owners had exaggerated his behaviors.

It's a very emotional experience to foster a dog; I know each time that I will likely never see that dog again. I could only keep Max for a month, and I hoped each day someone would adopt him. Just as time was running out, Friends of Homeless Animals rescue stepped up to foster Max and help find him a forever home.

Sometimes it takes a village to save a dog. We at Hounds Town were just one stop on Max's journey—a journey that I hope ends with Max living the years he has left surrounded by the love that every dog deserves.

Jackie

Wylie
Corgi Mix

In the fall of 2013, we decided to adopt a dog. We both like different breeds, so it was hard for us to find one that we could agree on. Then we saw a photo of Wylie online. His tongue was sticking out, and we both thought he was adorable. So we rented a car and drove from New York City to Newark, New Jersey, to meet him.

It was heartbreaking to visit the shelter. While the dogs were clearly receiving good care, it was sad to see them in kennels. An employee led us down a long row of cages filled with large dogs, all barking and jumping. All the way at the end, with his short legs and wagging tail, was Wylie. As he was led out of his cage and toward the exit, he was so nervous (or excited) that he pooped in the middle of the hallway!

We brought him outside, and he basked in the sunlight. He was so happy to meet us and receive affection. We knew instantly that he was the dog for us.

Almost two years after adopting Wylie, we can't imagine life without him. He loves belly rubs, howls at us when we come home from work, tries to French kiss everyone—and usually succeeds.

Emily and Matt

Maggie
Goldendoodle

When we first saw Maggie, we just couldn't get over how sweet and cute she was. Holding her in our arms just gave us such a warm and loving feeling.

Before we adopted Maggie, we did our research on the goldendoodle breed and felt that it would be the one for us. Maggie was eight weeks old and just the cutest, sweetest dog we could have chosen. She passed all the puppy tests, and we knew right away that this was the puppy to join our family.

On the way home, we cradled Maggie in our arms. She settled right in and looked so comfortable. We set up a big crate in the family room, and our children loved going into the crate to teach her that it would be a safe place for her. For the first several days, the children slept with Maggie so she wouldn't feel scared or nervous in her new home.

Maggie has a great personality. She will come right up to you, and while you are petting her, she will put her paw right on your thigh. Whenever we return home and enter the house, she paces in excitement for several minutes before she calms down and knows we are home to stay.

Maggie likes to have fun and meet new people. She is a free spirit and a great teacher. For a while, we took in various puppies to help socialize them, and Maggie was right there to play with them and teach them. We also were involved with training a service dog through the NEADS (National Education for Assistance Dog Services) program, and Maggie was a great help.

When Maggie was four years old, she was certified to be a therapy dog and then a reading partner. She has visited nursing homes, college campuses, winter and summer Special Olympics events, and the children's room in the library (as a reading partner). At every visit, we receive so many compliments about our Maggie. She not only brings joy to us, but also to everyone she meets.

Diane

Faith
Pit Bull and Cocker Spaniel Mix

Faith's story began almost thirteen years ago. She was born in a town near Boston, in a home with a large family. Her mother had five puppies, and my friend is related to the family who owned them. I was not looking for a dog. I was nineteen and living at home; I just wanted to see the babies.

The pups were all black and floppy-eared. Faith was the only one that did not have droopy eyes; she was a tiny peanut, the runt. She came to me first and asked me with her puppy eyes to hold her, and that was all it took.

Several weeks later, when I brought her home, my mother protested that I should not have my own dog until I figured out what I was doing with my life. After just one night, I sent my friend to take Faith back to the family. About twenty minutes later, I got a phone call that Faith would not stop crying. I made my mom listen to the puppy cry, and I picked her up that night! I named her Faith because I knew she had faith in me to be her mom.

Over the years, Faith has overcome some very difficult things. She is dog selective, has some separation anxiety, and has endured moving around. No matter what, though, she's always made the best of it! She just needs a blanket she can ball up exactly how she likes, food, water, and her mom. She's made a lot of two-legged friends and gained some four-legged ones, too.

You can often find Faith snuggled up with her feline family members or her favorite canine brother, Tonka Dog. She knows tricks and is a pro with obedience. She has always been able to put a smile on my face, no matter what is going on.

I've been blessed with Faith and am so glad I did the irresponsible thing and got her when I did. She's inspired me, in a way, to become a veterinary technician and to dedicate my time to helping animals where I can.

Mechelle

Edie
Chihuahua Mix

I first saw Edie on Petfinder; I could tell she was awfully cute (and a good size for apartment living). When I met her at her foster mom's home, she ran up to me and started licking my feet. I sat on the ground and she climbed onto my lap, looking quite pleased with herself. It was love at first sight.

Edie was adopted from a private rescue group when she was about eight months old. I found her by searching for pug mixes on Petfinder, even though I'm pretty sure she has next to no pug in her lineage (her foster family had no clue as to her origins and listed her as a puggle). Her foster parents had dubbed her Mimi, but I thought Edie suited her.

All I know about Edie's background is that she was found in an abandoned house in Tennessee. The image of a tiny, scared puppy alone in an abandoned house still breaks my heart.

Edie was instantly affectionate with me. She gave me lots of kisses and let me touch her without reservation, which blew me away considering her history. She is just so happy and loving and full of puppy ridiculousness. When she wants attention, she can be very insistent (my laptop is her biggest rival), and she loves chest rubs.

Edie's cutest attribute is her ears, which stand upright with the tips flopping over. Occasionally, one of them will "freeze" fully upright. (It's not really frozen, but it does seem to happen more often when the weather is cold!) She also cocks her head when I ask her a question.

Maybe it's a small dog thing, but Edie is definitely a bit cautious (except for the first time she confronted a porcupine!). She likes her personal space and feels more comfortable initiating affection and attention, especially with other dogs.

Despite Edie's uncertainty at times, she is extremely patient and tolerant, with children in particular—she will tolerate sudden, overwhelming attention from a child that she would never accept from another dog!

Liz

Bing
Labrador and Terrier Mix

My dog, Bing, is a rescue pup my family and I got from a kennel in Indiana four years ago. He was born in the kennel, so we took him home when he was nine weeks old.

As Bing has become an integral part of our family, he has demonstrated a wonderful disposition and an ability to play with any other dog—from a ridgeback to a dominant female poodle who terrorizes every other dog in the neighborhood! He gets along with everyone, including our four sometimes overly affectionate grandchildren.

My buddy, Bing, has so many great attributes. My routine in the morning is to have a cup of coffee and read the paper. I have a favorite chair I sit in, and I generally take about thirty minutes to read the entire paper. Bing is usually upstairs with my wife while I'm reading the paper, the two of them still in bed. Unfailingly, in some extrasensory manner, Bing knows when I am done reading the paper, which means it's time for him to come downstairs to go for a walk around the neighborhood. I never have to call Bing downstairs for his walk, and there are no indications for him that I have finished the paper, such as putting it aside or getting up to go elsewhere. Within seconds of finishing reading, Bing comes bounding down the stairs and sits at my feet with his tail wagging like crazy and a big smile of anticipation on his face. This is how the two of us start our day.

Every morning I can count on him to bound off the bed and run downstairs. That is his time, and we never miss it.

Mike

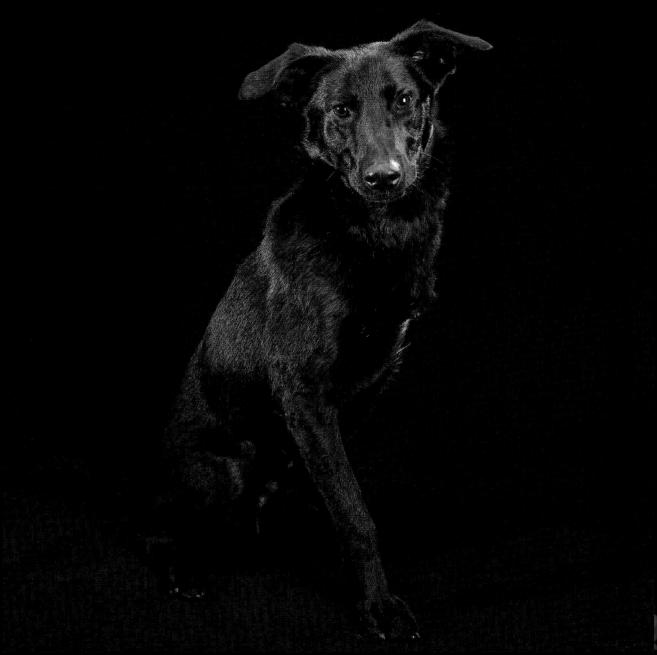

Booker
German Shepherd and Labrador Mix

When we first met Booker, we were blown away by his temperament. He seemed eager to jump in the car and start his life with us.

We had been talking about getting a dog for a few years and found a great dog with three legs named Tres, but when we got to the rescue, Tres had been adopted by someone else. Our contact mentioned that there was another three-legged dog who had a great temperament. Four days later, we brought Booker home to start his new life.

We can't imagine what life would be like without Booker around. He was found on the side of the road in Mississippi with his sister. A couple picked them up and called the local rescue to drop them off. His front paw was twisted and he was in great pain. They had to amputate his front leg, but after his recovery, we were told that he came running out of the shelter and jumped up into the back of a pickup truck. He was a totally new dog.

Booker is well known in the community. We think he really loves the fact that he has such a large fan club. Policemen, firemen, construction workers, and almost all others who come in contact with him love when he jumps up to give hugs. When we get home from work every day, Booker comes out of his crate in a frenzy of excitement. After a long day of commuting and working, any stress melts away.

Booker has many cute quirks, but our favorite in particular is this high-pitched sound he makes when he yawns. Because we laughed at him when he first did it, he started to do it when he wanted to make sure we paid attention to him. It is the cutest thing, even at 5:00 a.m.

There have been so many instances where people meet Booker and comment about how inspiring it is that he can get around so well and be so happy. He knows no different, and he amazes us with his abilities every day.

Paul and Dayna

Olive
Goldendoodle

I knew I wanted a black dog for a couple of years before I got Olive. Her name came first; I read and adored the book *Olive Kitteridge*, and the title character is black and has the personality I knew I would love in a pet. Olive has certainly lived up to her namesake. As it turned out, I had the pick of the black dogs from the litter because they were the least popular. The breeder told me it's because they are so hard to photograph!

Olive's most notable feature is that she looks you right in the eyes. From the moment I picked her up, she has never taken her eyes off me! On the plane ride home, other passengers kept commenting on our connection, and I had only had her for a few hours.

A few months before we got Olive, one of our bearded collies, Jackson, passed away suddenly. Although he was thirteen and a half, we were not expecting this loss—and neither was Scout, our other dog. When Jackson died, Scout fell apart.

Since we have been a multiple dog family for many years, we knew we wanted to get another dog. Scout's trainer suggested the goldendoodle breed, because such dogs are confident and sweet. And that is exactly the impression I had when I first met Olive.

Olive has only one toy that she likes: a green ball. We taught her to ring a bell when she needs or wants to go outside. But she has found another use for the bell; if Scout is chewing a bone that Olive wants, Olive will simply ring the bell and Scout will get up, leaving the bone behind!

Olive is very connected to both Scout and us. When Scout had surgery a few weeks after we got Olive, Olive stayed right with him, sleeping with her head on him to comfort him. She does the same with me. She had big shoes to fill after Jackson's loss, but she has made her own place here and is loved by all of us.

Terry

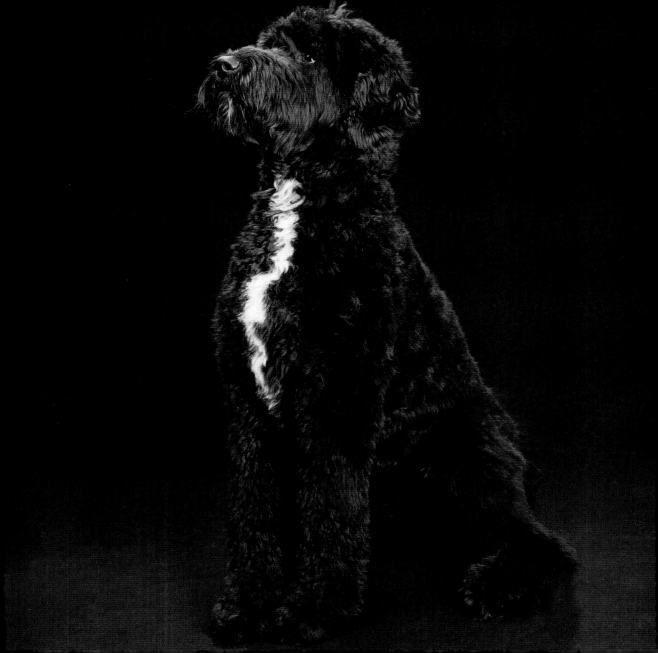

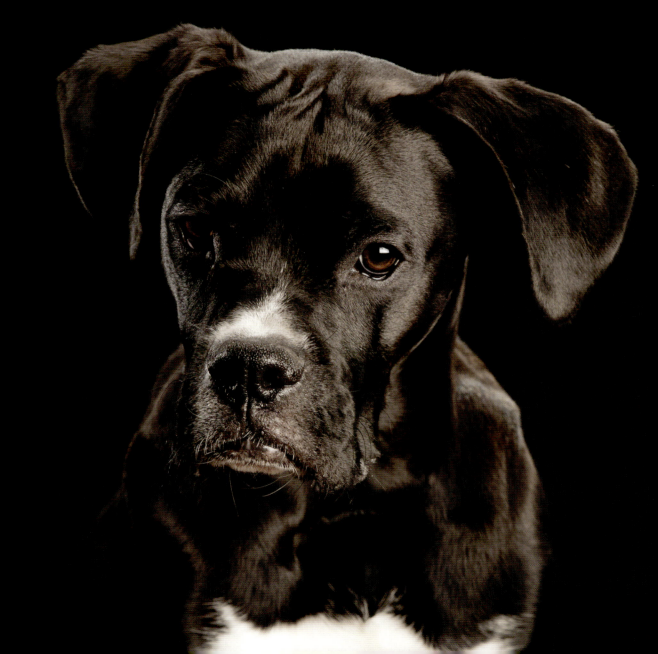

Stout
Boxer

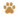

I rescued Stout in Miami exactly four days after losing my previous boxer, Dubz. I flew to Miami International, scooped him up at the airport, and flew back home to Massachusetts with him.

Despite the flutter of guilt I had for getting a new dog so soon, the feeling passed the moment I held Stout. It was then that I knew I had made the right choice. After losing Dubz, who died unexpectedly at a young age, I was lost and barely spoke a word for three days.

On the fourth day, I woke up and came to the realization that I had to accept that Dubz was gone. I thought of our best days together, and then it came to me: I was going to rescue another dog. Without a second thought, I opened my laptop for the first time in a week and started searching dog rescues. I landed on a blurry photograph of what looked like a black boxer mix. He was eight weeks old. Within an hour, I had a flight booked to Miami and arrangements made to pick him up the following morning.

The moment our eyes met, I knew Stout was meant for me. I think the thing he appreciates most is my unconditional love. He is always aware of where I am, and he is loyal to the core. He still watches over me today as he has since day one.

Stout's facial expressions are priceless. His grunts are epic. He has no problem letting you know what he wants and when he wants it. He loves all creatures and has great patience—he loves playing with children and meeting new people. We have traveled many miles together in the past year and a half—from Massachusetts up to Vermont and out to West Virginia and back again. He is my cocaptain, not only on the road but in life. We are a team, and together, we want to help make the world a better place.

Kim

Murphy
Labrador Mix

We adopted Murphy from Save A Dog, which had rescued him from a shelter that had picked up Murphy and another dog when they had been running along the side of a road in Kentucky. Save A Dog brought him up to a foster home in New England, where he would have a better chance of being adopted (and we're so lucky they did!).

Our first glimpse of Murphy was a grainy photograph on the Petfinder website. He was a gangly one-year-old with a big, goofy grin, and something told us that he would be a perfect addition to our family. I called the number and set up a time to visit his foster home. As soon as we stepped in the backyard, Murphy came bounding over with a ball in his mouth to play, and the rest, as they say, is history.

Murphy is the most loyal friend—the kind of guy who'd give you the shirt off his back. Every time I was pregnant, he would guard me as I ate. He wasn't begging for food or lying under the table (which is what he'd normally do). He would sit with his back to me, at attention, until I was finished with my meal, and then he would go lie down. He only ever did this when I was pregnant—a couple of times it seemed he knew before I did!

Another one of his talents is that he knows exactly when it's 5:00 p.m. (dinnertime!). He'll walk over and nudge my hand with his nose as if to say, "Hey, it's food time."

Murphy is the sweetest dog—goofy, wonderful with kids, and friendly with other dogs. When people meet him for the first time, I assure them that the most dangerous part of him is his tail!

Brad, Trischa, Ronan, and Kevin

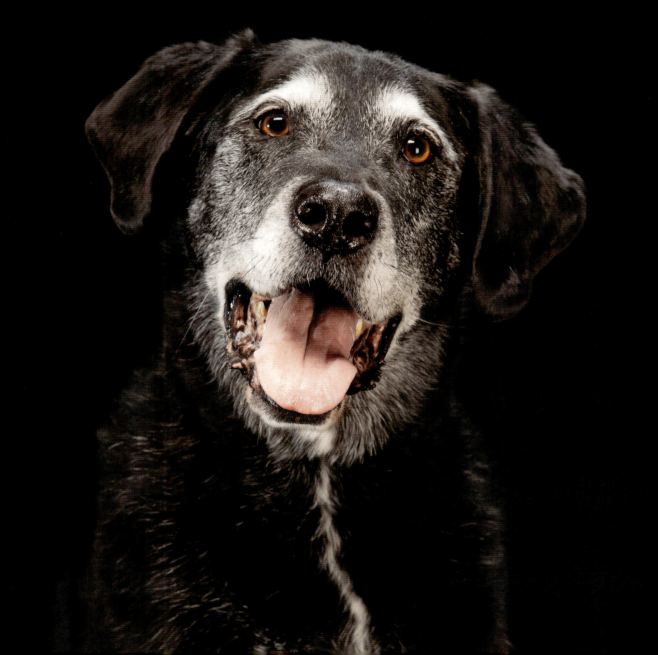

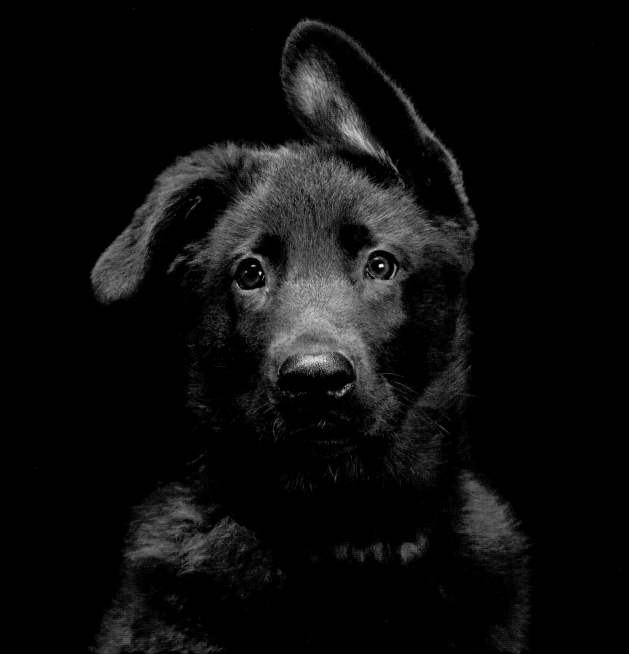

Pawnee
German Shepherd

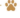

When I first saw Pawnee, I was beyond emotional. He had taken a four-day journey by volunteer transport from Mississippi to Massachusetts. Everyone who helped transport him meant so much to me, and they are still very close and continue to follow his journey.

Pawnee was born just hours after I had to put my best friend, Roxie, down from Lyme nephritis. She had been an all-black German shepherd, just like Pawnee. I know Pawnee was meant to be with me because he has a part of Roxie in him. I think he was sent from Roxie because she knew I was heartbroken over her loss and needed a new friend. He has never replaced her, but made her loss easier to handle. The moment I held him in my arms, I knew he was meant to be mine and to help me cope with the hard life I was living.

When I first brought Pawnee home, I think he appreciated all of the love and all of the fun I had to offer him. He does many things that make me realize he loves me, but most of all, he knows my feelings and consoles me when I'm sad or down. He is always smiling! If he were a person, Pawnee would be a great friend and a giver.

Pawnee and I have been through a lot together, and I think the bravest thing he has ever done is drive with me from Massachusetts to Nevada and listen to me talk, sing, laugh, and cry the whole way. He never left my side.

Pawnee is wonderful with children, adults, and other animals. He is filled with love and people can feel that.

Nicky

Tuxedo
Briard

"How do you solve a problem like Tuxedo?" That's the question! I first fell in love with the breed when I got a briard for my husband, Charles. He had had a briard years before, and he said they were the best dogs in the world. Our first briard, Tasha, was one of the most gentle, loving beasts I've ever met. She made an impact on our whole family.

After we lost Tasha, I found myself pining for a briard—there was a briard-shaped hole in my heart. And so I went looking for an adult briard whom I could rescue because I didn't have the time to raise and train a puppy.

In came Tux! He needed a home the way I needed a briard. He had been an award-winning show dog, but had been removed from his home because he was neutered, and the breeders' unneutered male dogs were no longer friendly toward him. He had also been attacked as a puppy, and he had a fear of other dogs being in his face. When he came to me, he needed a lot of love and retraining to be comfortable with the world around him.

I've since worked with trainers and spent a lot of time just nurturing him, and now my Tux is a happy, well-adjusted boy! Well, a big "boy"—he's about ninety-six pounds (44 kg)! The one real problem left is that he's a mischievous creature, a real Puck/Robin Goodfellow of the dog world! He needs lots of exercise or he gets into trouble at home, especially stealing food (meats, bread, cheeses, tomatoes, avocados, even a whole pie once!).

But somehow that only makes me love him more. He's a real character, his own person, and I love all of him. And what is more, he loves me, too—we are totally bonded. We both look forward to our grooming sessions in the evening, when I brush out his knots and he licks my hands and arms while I brush him. I'm so lucky to have been able to give him a safe haven.

Beverly

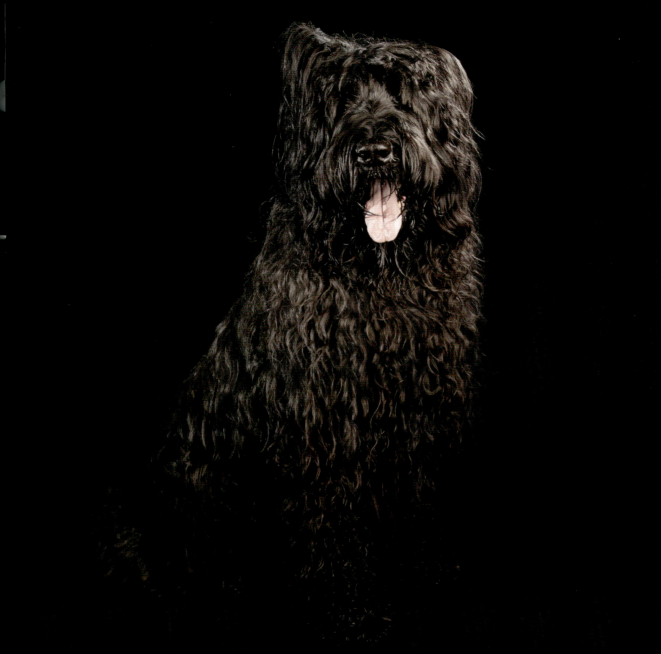

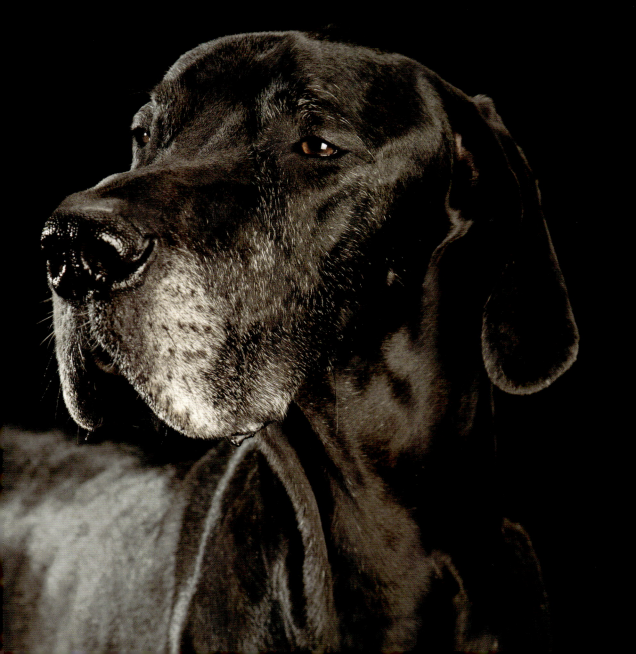

Tyson
Great Dane

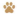

I met Tyson after I was called to foster a sick puppy. When I first saw him, I was so sad to see a sixteen-week-old puppy that sick but happy that I was able to help him become safe and healthy.

When he first came to us, Tyson was emaciated and had parvovirus and a joint disorder. Once he was strong enough to come home from the hospital, we got him to a healthy weight, treated him with medicine to address his joint deformity, and began working on his shyness.

After fostering Tyson for ten months, he was finally strong enough to go on walks. We decided that he was a member of our family and we couldn't imagine him anywhere else.

Because he was so sick in the beginning, Tyson was unable to be socialized and developed a fear of almost everyone and everything. It took about a year to work through it, and that's when I tried something new: competition obedience training. He loved it! We began doing more training in the obedience ring, and he continued to thrive.

Tyson has become a rock star in both obedience and rally performance events. He is a spokesdog for our rescue, Great Dane Rescue of New England, showing the world that being a rescue dog doesn't mean he is broken. I think the bravest thing he's ever done is strut into the performance ring at the National Great Dane Specialty in front of hundreds of spectators, proud to be what he is. He walked away with fourteen ribbons, two trophies, two titles, and proof that rescue dogs rock!

I think what Tyson appreciates most about being rescued is having a warm home and just being loved. He could sit on your lap for hours. He has a light in his eyes when he sees me and, of course, lots of tail wags.

From the minute I picked Tyson up and held him in my arms, I knew he was mine. Certain ones just capture your heart as soon as you meet them, and he was that one for me.

Rachel

Ransom

Great Dane

When I first saw Ransom, I saw the most tender and soulful eyes. There was an immediate bond between him and me. I knew instantly he was an old soul.

When we picked him up, Ransom was just what we were hoping for: sweet, lovable, and very happy. Soon after we brought him home, Ransom started participating in fundraisers on a stage in front of crowds of people, and then he began his showing career, participating in conformation and performance events. He has accomplished so many things and has multiple titles.

Ransom works with me as a canine evaluator for Great Dane Rescue of New England. He meets every Great Dane that comes through the rescue. He has a very calm way about him and puts even the most nervous dogs at ease. He has become a big part of what we do and is an amazing representation of the Great Dane breed. If Ransom were human, he would be that cool, calm, and collected person. The go-with-the-flow kind of guy.

He is so well mannered and so in tune to the world around him. I have an ill father, and Ransom alerted me when my dad had fallen outside—he seems to have a sixth sense to know when something is wrong or different. It takes a special kind of dog to do what he does.

I think what Ransom appreciates most is being loved. He is such an amazingly good dog. He follows me everywhere and loves to sit on top of me and be a lapdog. He gets excited to see me even if I only go outside for a minute. He will lick your face every time you look at him and grab his jowls, and he would kiss you until your face fell off!

Ransom has become my soulmate in life. He holds a very big piece of my heart and has truly been a gift. He brings brightness to every day. He has these eyes that have such an endearing look, as if he has been around for a thousand years.

Rachel

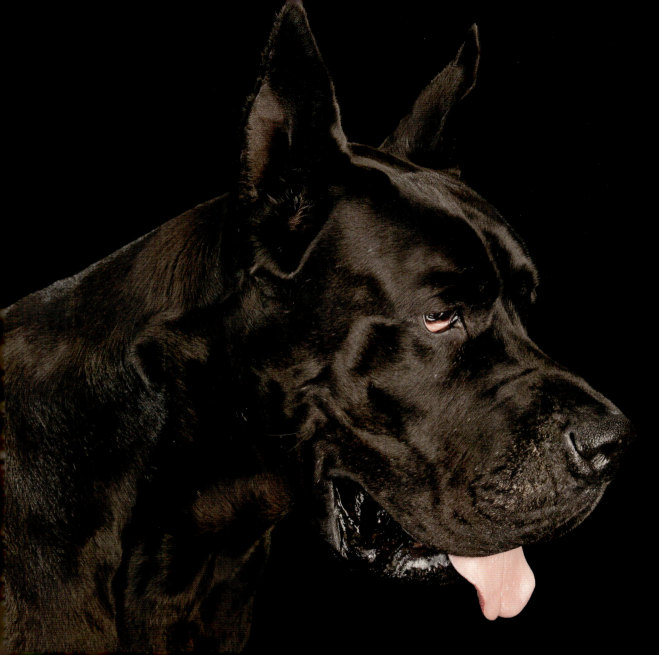

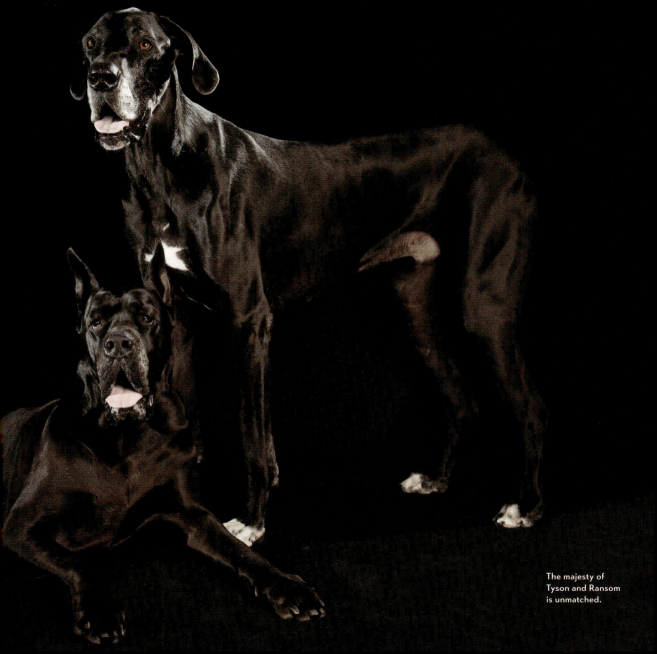

The majesty of Tyson and Ransom is unmatched.

Acknowledgments

Special thanks to Jeannine Dillon, Jackie Bondanza, Sophie Yamamoto, Erin Canning, Alan Chong, Johanna Levy, Jeff McLaughlin, and the team at Quarto for producing this beautiful book.

I'm also grateful to Maggi Berwind-Dart at Black Dog Rescues, Lauren Dube at Labradors and Friends Dog Rescue Group, and every single person who works in the animal rescue community. Your tireless effort to save the lives of the overwhelming number of animals in need is humbling and shines a light on what is possible when we show a little humanity.

Finally, I'd like to express my sincere gratitude to all of the dogs and their families who participated in the Black Dogs Project and shared their stories to help make Black Dog Syndrome a thing of the past.

About the Photographer

Originally from California, Fred Levy made the move to Massachusetts in 1995 to attend graduate school. He worked in higher education for most of his time in Boston until he decided to go out on his own to focus on his family and his photography.

He started shooting for the Black Dogs Project (caninenoir.tumblr.com) in 2013, and the blog was ranked by Tumblr as one of the most viral blogs in 2014. Since then, Levy's black dog photos have been shared all over the world, and he has been interviewed and featured on television, the *Huffington Post*, the *Daily Mail*, *Boston.com*, and many more.

Levy is married with two amazing children that keep him on his toes and dogs Iggy and Jack-Jack, who are constant sources of inspiration. If you ever want to get him talking, just mention the latest photo gear, a nerdy current event, or of course, your pet.

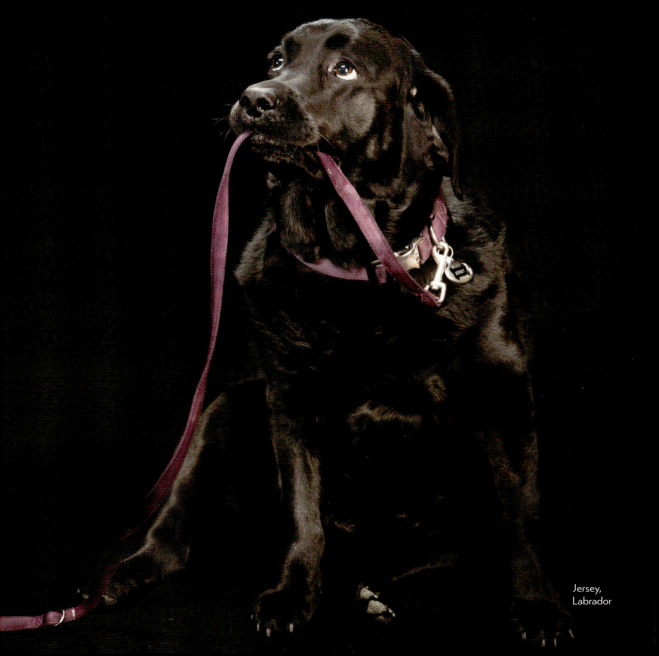
Jersey, Labrador

About Labradors and Friends Dog Rescue Group

Labradors and Friends Dog Rescue Group is a 501(c)3 animal rescue group whose mission is to help save the lives of homeless Labradors, Labrador mixes, and Labrador "friends" from kill-shelters in California and across the Southwest. Founded in 2007, the all-volunteer group of dedicated men and women has placed over 6,000 dogs in loving homes in Southern California and the surrounding areas.

Labradors and Friends Dog Rescue Group is dedicated to saving the lives of black dogs, who often face the challenge of being overlooked in shelters. Black dogs are the fabric of the rescue and how they enrich human lives is the motivation for the rescue workers. When you visit the rescue's website, you'll notice a theme: many wonderful black dogs seeking homes. Despite their loving nature, black dogs are often the last to get noticed in shelters, placing them in the most danger.

Over the past few years, Labradors and Friends Dog Rescue Group has noticed a dramatic increase in the number of senior dogs and dogs requiring medical care who need rescue from high-kill shelters. In response to this need, Labradors and Friends Dog Rescue Group created two special funds to help these deserving dogs: the Agnes Fund was created to help cover the costs of caring for senior dogs, and the Paw Up fund was created to cover the costs of both major and minor medical needs. Looking toward the future we will be focusing on spay and neuter initiatives and programs to help keep pets in their homes through financial and medical support.

Labradors and Friends Dog Rescue Group is dedicated to changing the fate of Labrador retrievers, Labrador mixes, and Labrador "friends" by placing them in loving forever homes. Labradors and Friends Dog Rescue Group plays an important role in the local community by uniting people with their four-legged companions and helping to complete families.

At Labradors and Friends Dog Rescue, black dogs have our heart. For more information, visit labradorsandfriends.org.

© 2015, 2025 by Quarto Publishing Group USA Inc.

Photography © 2015, 2025 by Fred Levy
Photo page 17 © by Lauren Dube

This edition published in 2025 by Epic Ink, an imprint of The Quarto Group,
142 West 36th Street, 4th Floor, New York, NY 10018, USA
(212) 779-4972 www.Quarto.com

First published in 2015 as *The Black Dogs Project* by Race Point Publishing, an imprint of The Quarto Group,
142 West 36th Street, 4th Floor, New York, NY 10018, USA.

All rights reserved. No part of this book may be reproduced in any form without written permission of the copyright owners. All images in this book have been reproduced with the knowledge and prior consent of the artists concerned, and no responsibility is accepted by producer, publisher, or printer for any infringement of copyright or otherwise, arising from the contents of this publication. Every effort has been made to ensure that credits accurately comply with information supplied. We apologize for any inaccuracies that may have occurred and will resolve inaccurate or missing information in a subsequent reprinting of the book.

Epic Ink titles are also available at discount for retail, wholesale, promotional, and bulk purchase. For details, contact the Special Sales Manager by email at specialsales@quarto.com or by mail at The Quarto Group, Attn: Special Sales Manager, 100 Cummings Center Suite 265D, Beverly, MA 01915 USA.

10 9 8 7 6 5 4 3 2 1

ISBN: 978-0-7603-9450-2

Digital edition published in 2025
eISBN: 978-0-7603-9451-9

Library of Congress Cataloging-in-Publication Data

Names: Levy, Fred (Photographer), photographer.
Title: Black dogs : stories of love and friendship / photography by Fred Levy.
Description: New York : Epic Ink, [2025] | Summary: "Black Dogs features
 over 50 stunning portraits of photographer Fred Levy's Canine Noir
 series alongside heartwarming profiles about each dog and their loving
 companionship"-- Provided by publisher.
Identifiers: LCCN 2024029475 (print) | LCCN 2024029476 (ebook) | ISBN
 9780760394502 (hardcover) | ISBN 9780760394519 (ebook)
Subjects: LCSH: Dogs--Pictorial works. | Photography of dogs.
Classification: LCC SF430 .L527 2025 (print) | LCC SF430 (ebook) | DDC
 636.70022/2--dc23/eng/20240708
LC record available at https://lccn.loc.gov/2024029475
LC ebook record available at https://lccn.loc.gov/2024029476

Group Publisher: Rage Kindelsperger
Creative Director: Laura Drew
Managing Editor: Cara Donaldson
Editorial Assistant: Alyana Nurani
Cover Design: Scott Richardson
Interior Design: Silverglass

Printed in China

This book provides general information on various widely known and widely accepted images that tend to evoke feelings of strength and confidence. However, it should not be relied upon as recommending or promoting any specific diagnosis or method of treatment for a particular condition, and it is not intended as a substitute for medical or mental health advice or for direct diagnosis and treatment of a medical or mental health condition by a qualified physician. Readers who have questions about a particular condition, possible treatments for that condition, or possible reactions from the condition or its treatment should consult a physician or other qualified health care professional.